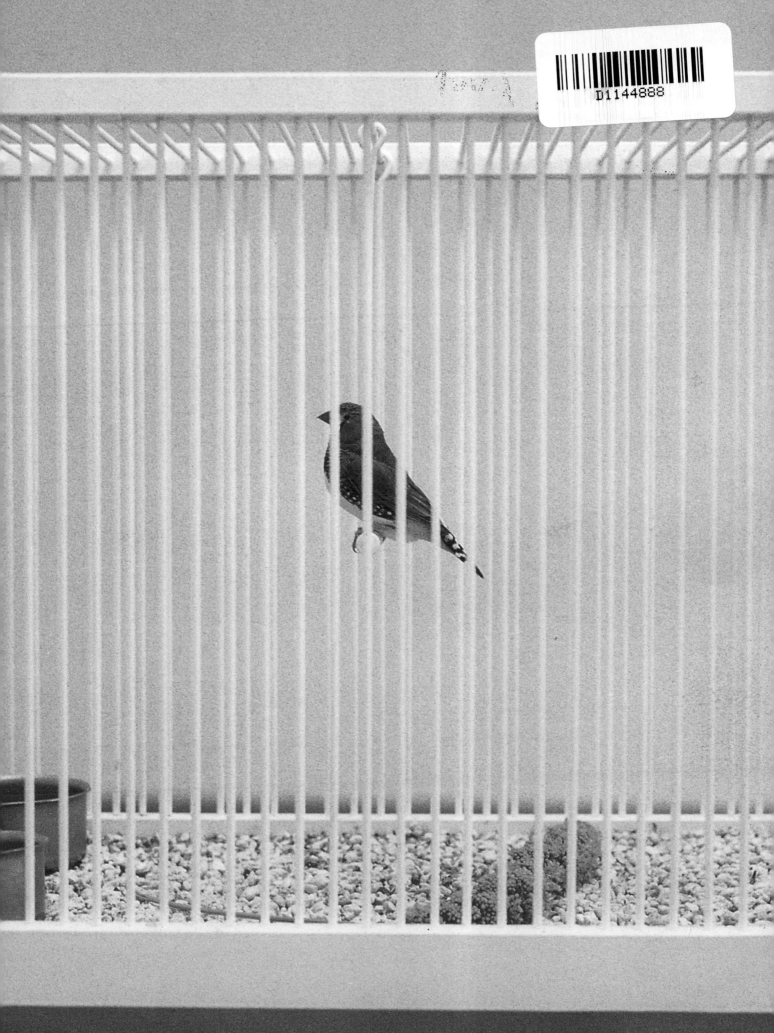

Bustamante

Flammarion Contemporary
Jean-Marc Bustamante

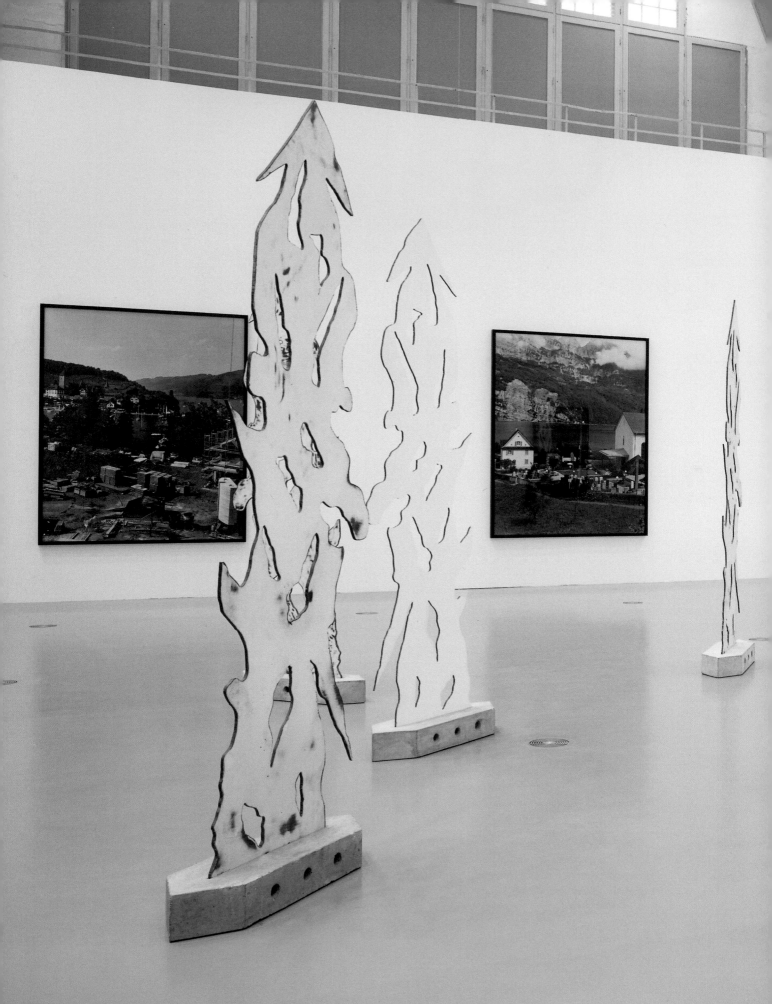

Arbres de Noël, 1994-1996

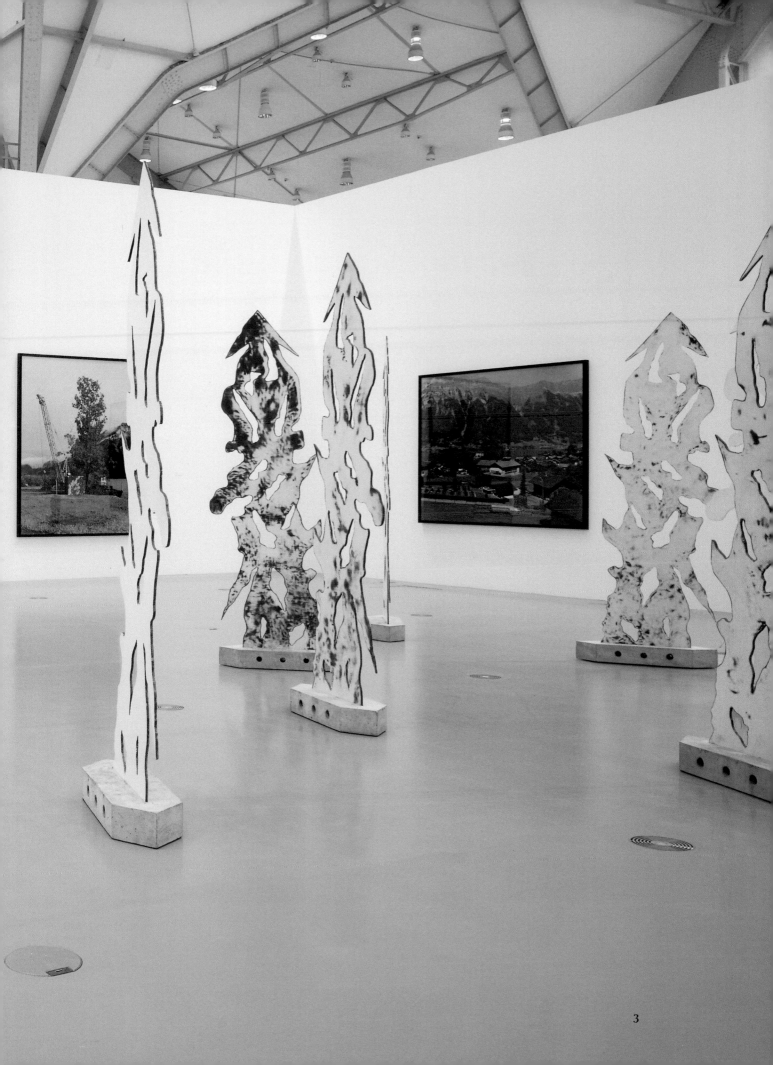

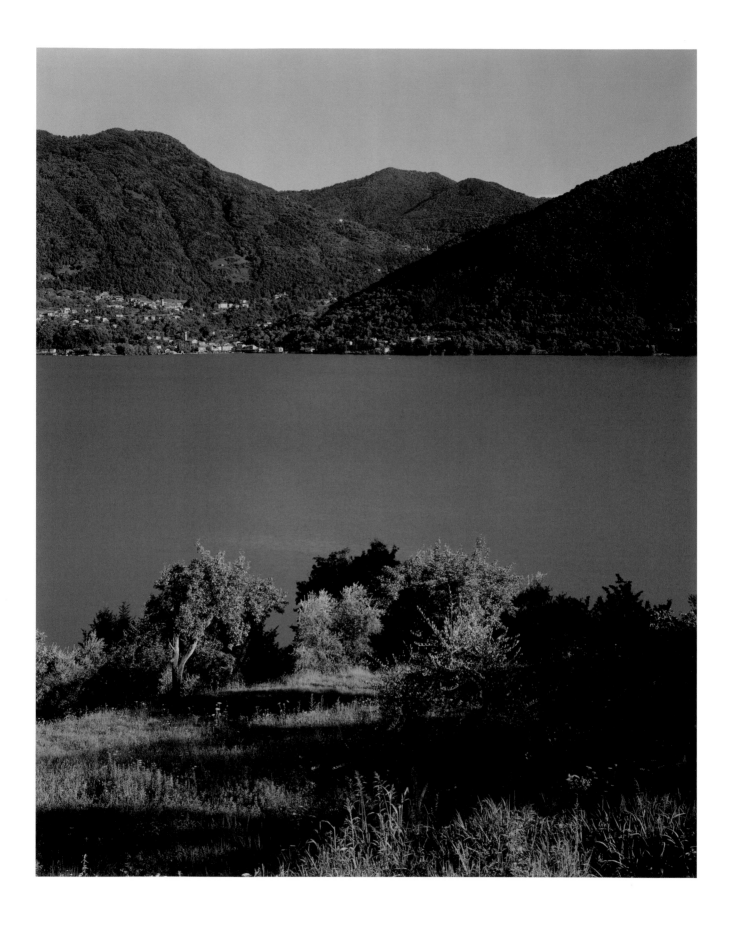

L.P.V, 2000

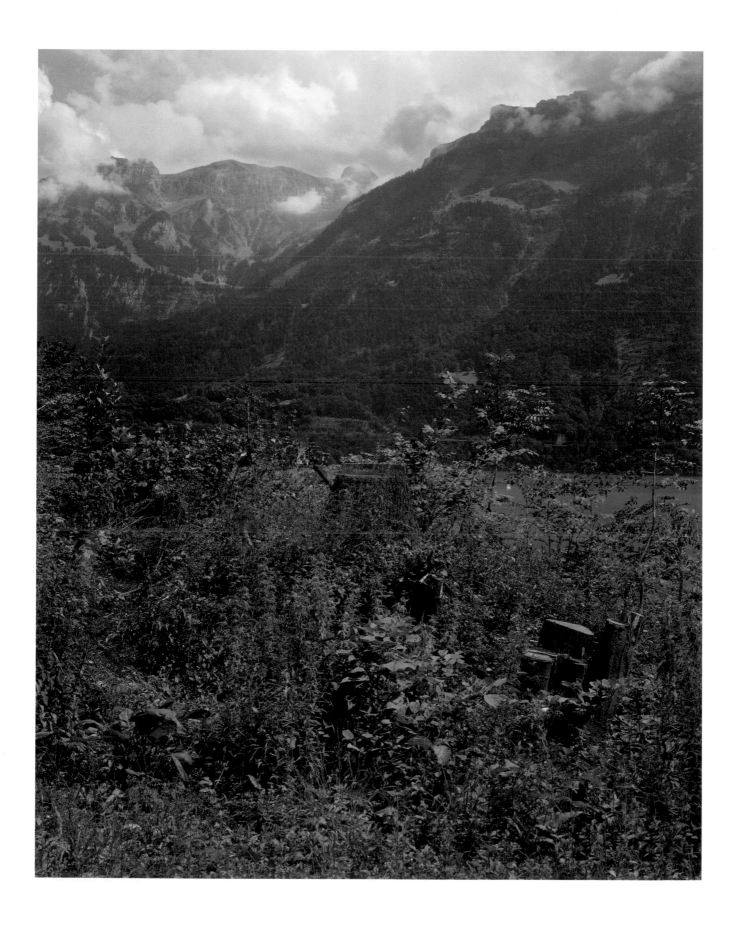

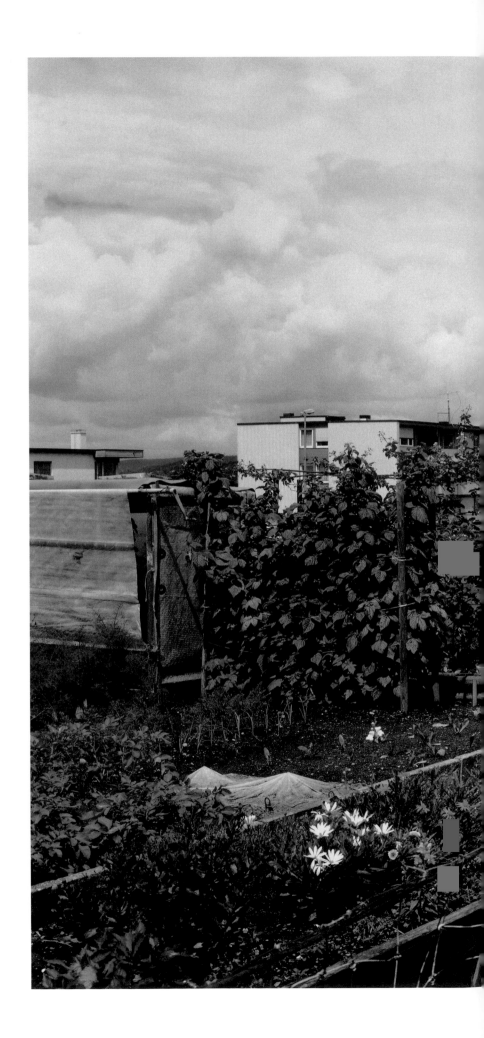

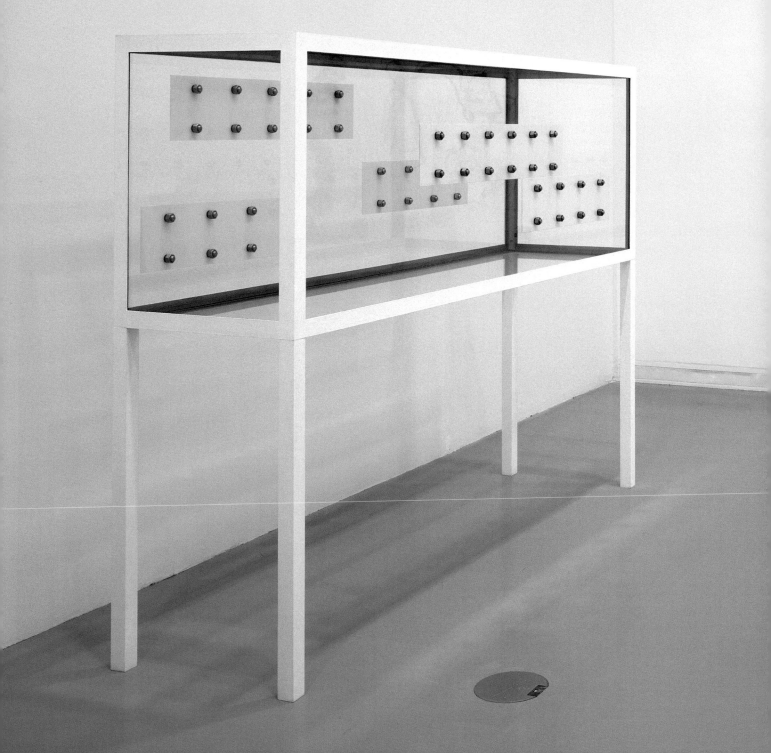

Aquarama I, 1997, **Panorama Wireless,** 2000

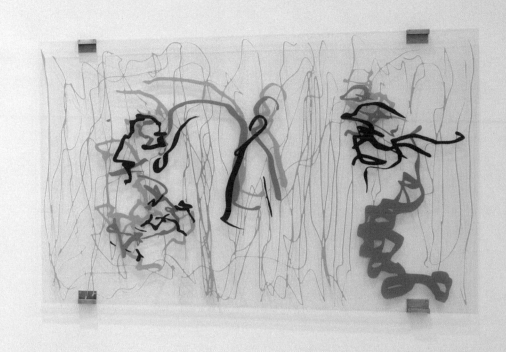

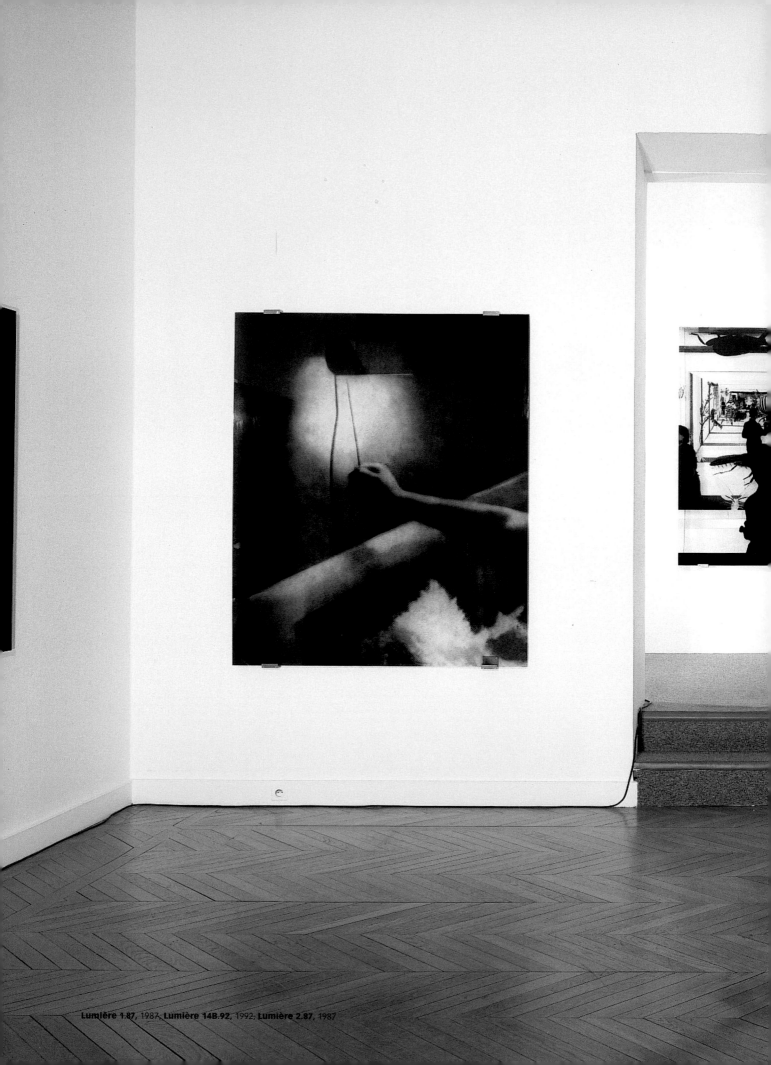

Lumière 1.87, 1987, Lumière 14B.92, 1992, Lumière 2.87, 1987

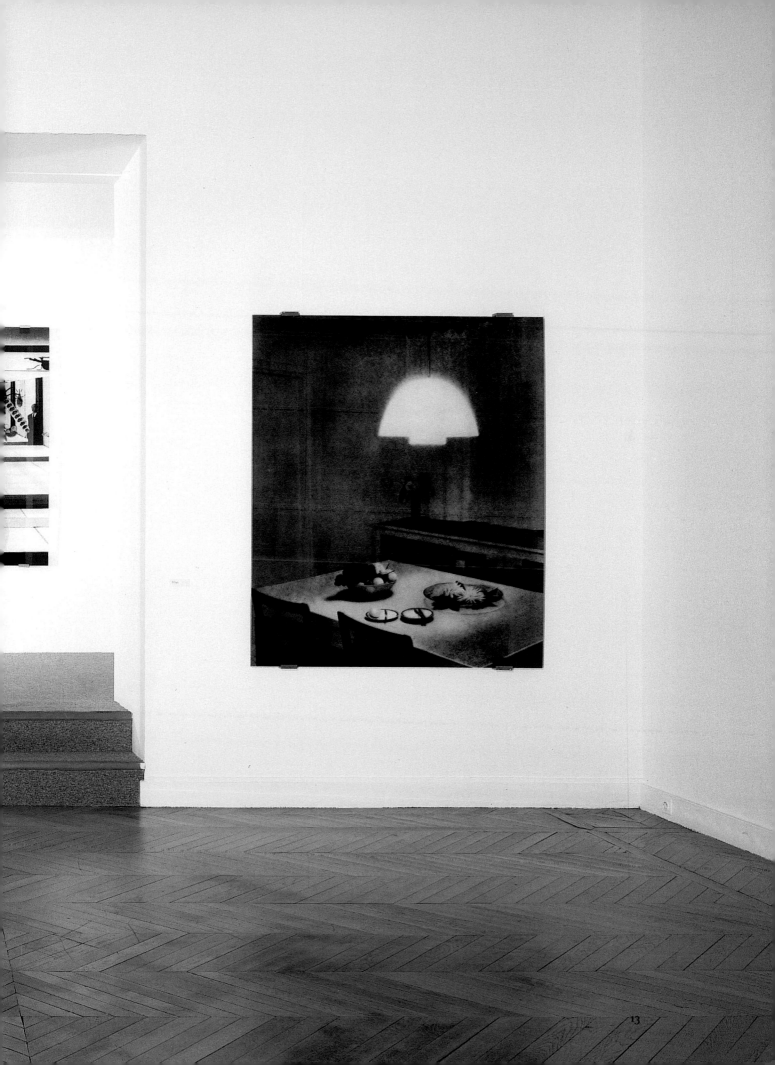

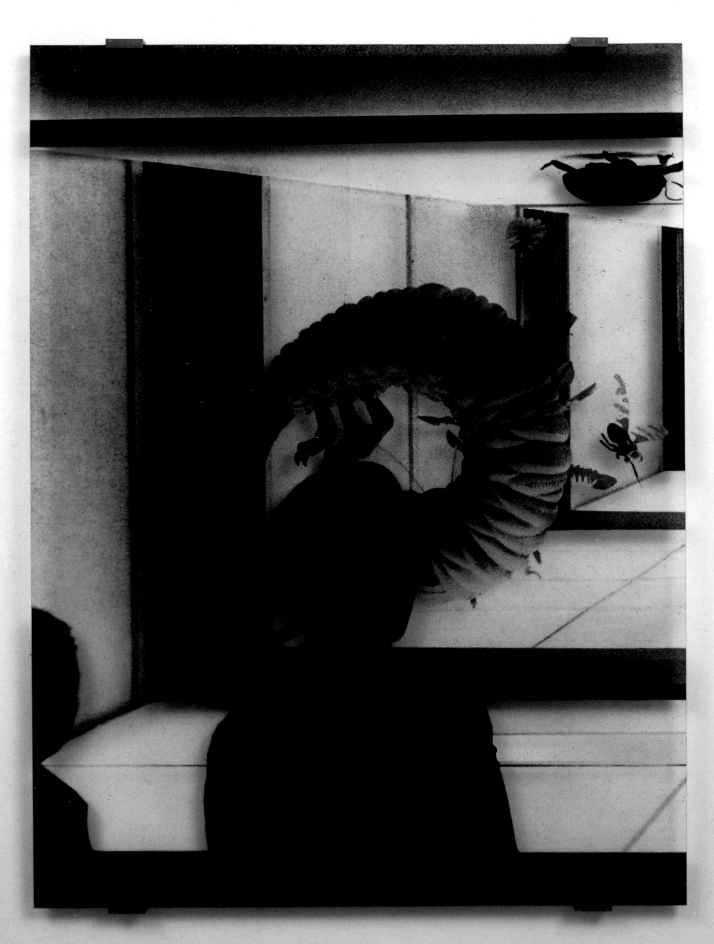

Lumière 14A.92, 1992

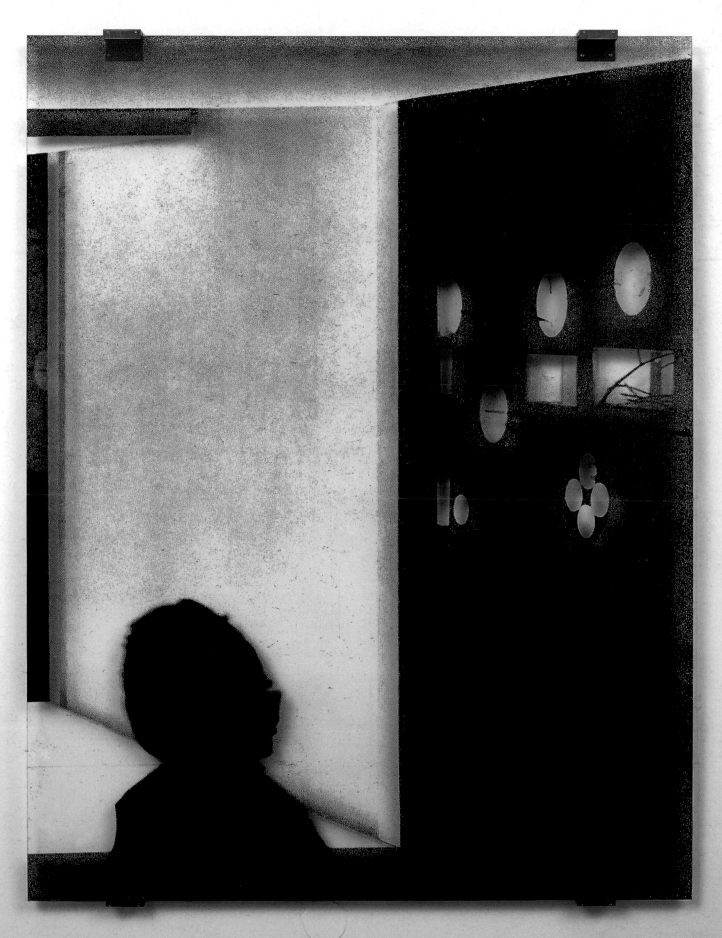

Lumière **14C.92**, 1992

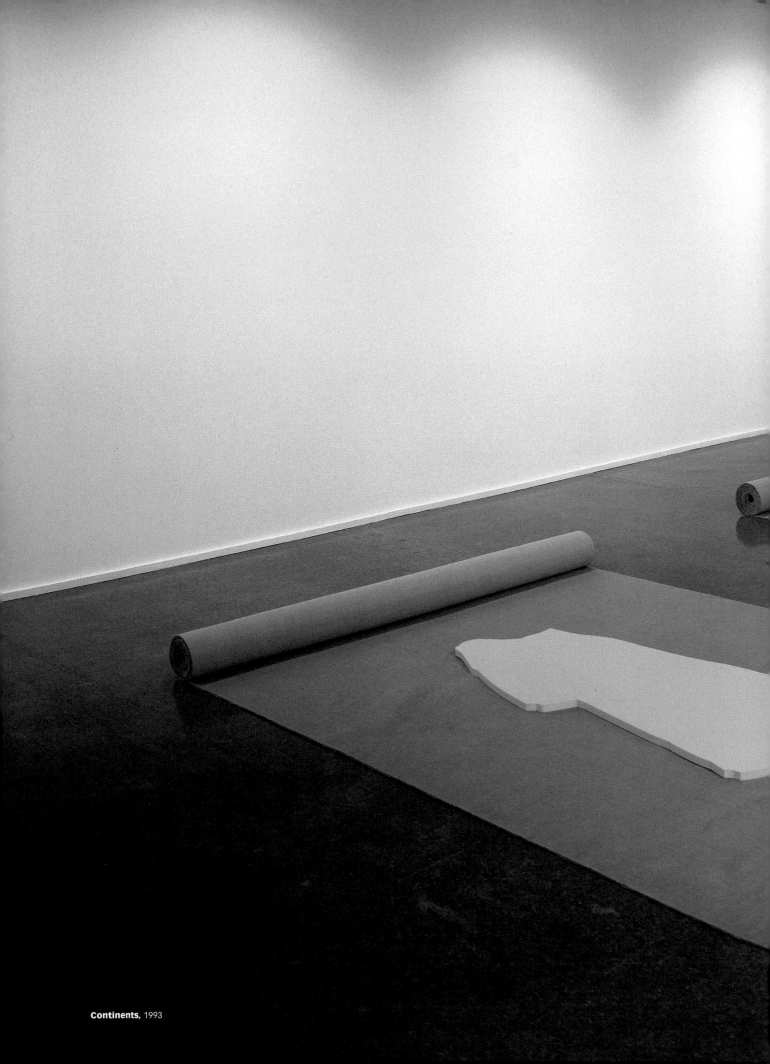

Continents, 1993

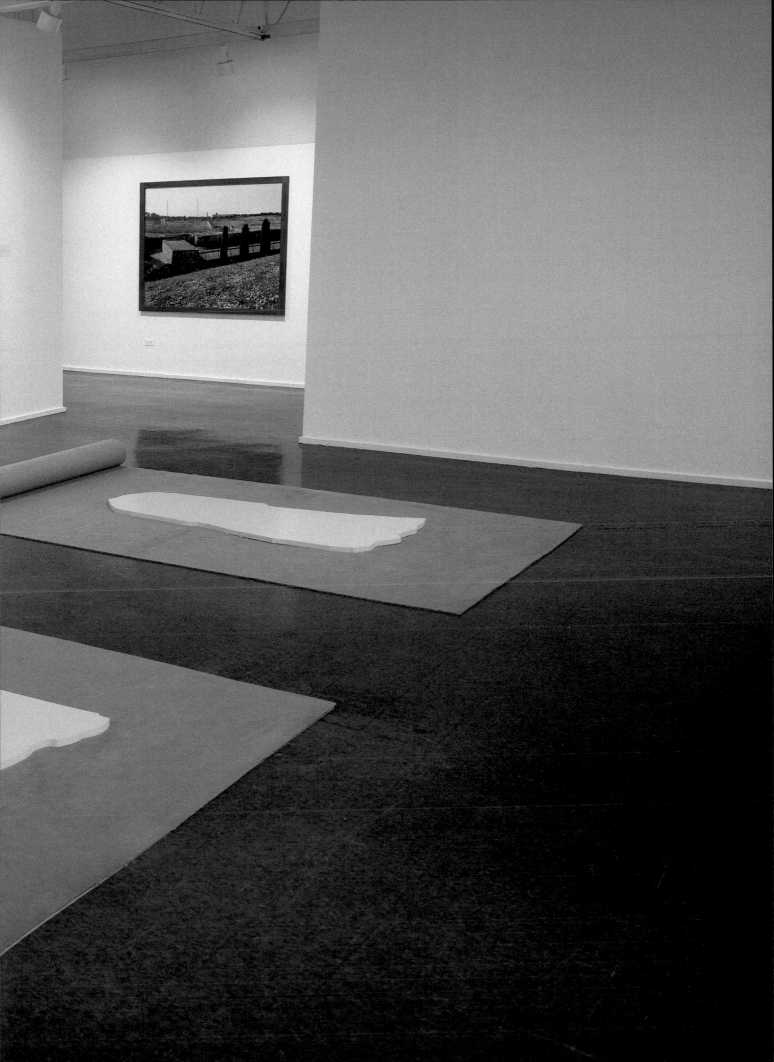

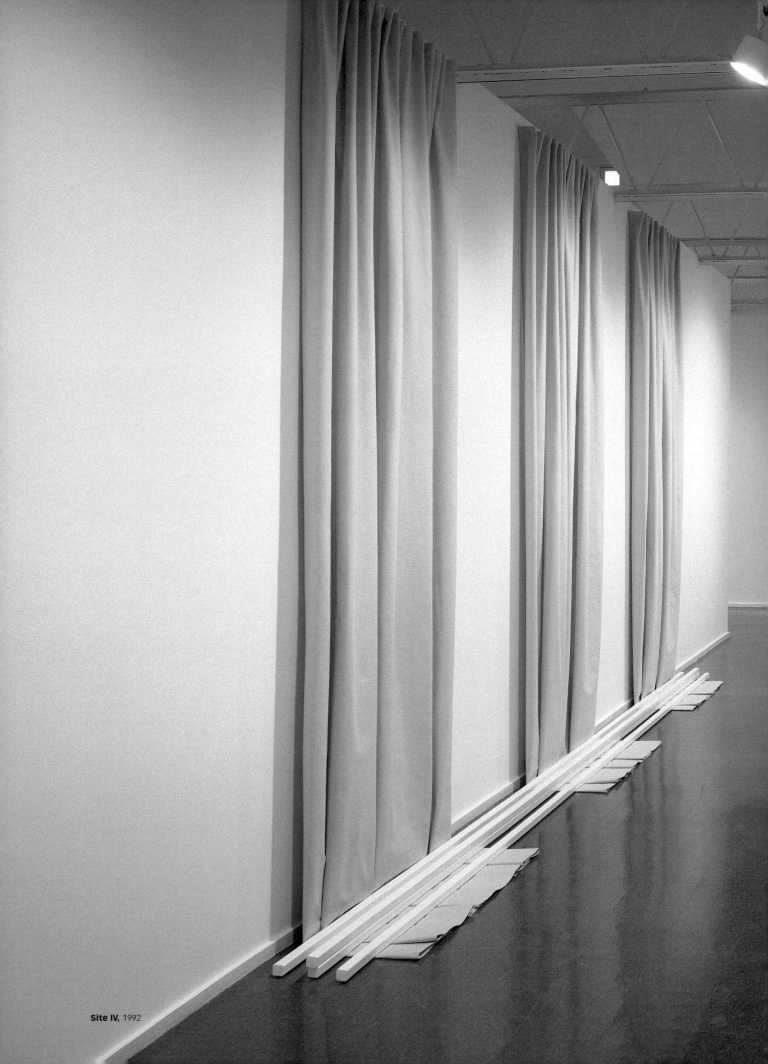

Site IV, 1992

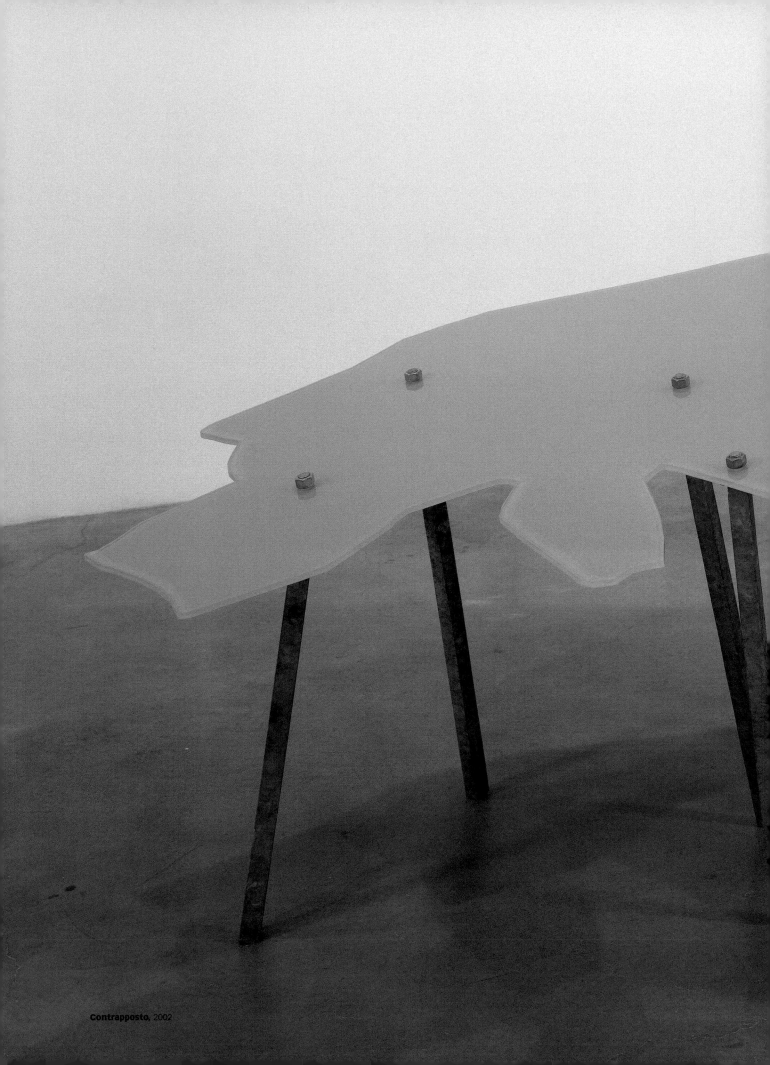

Contrapposto, 2002

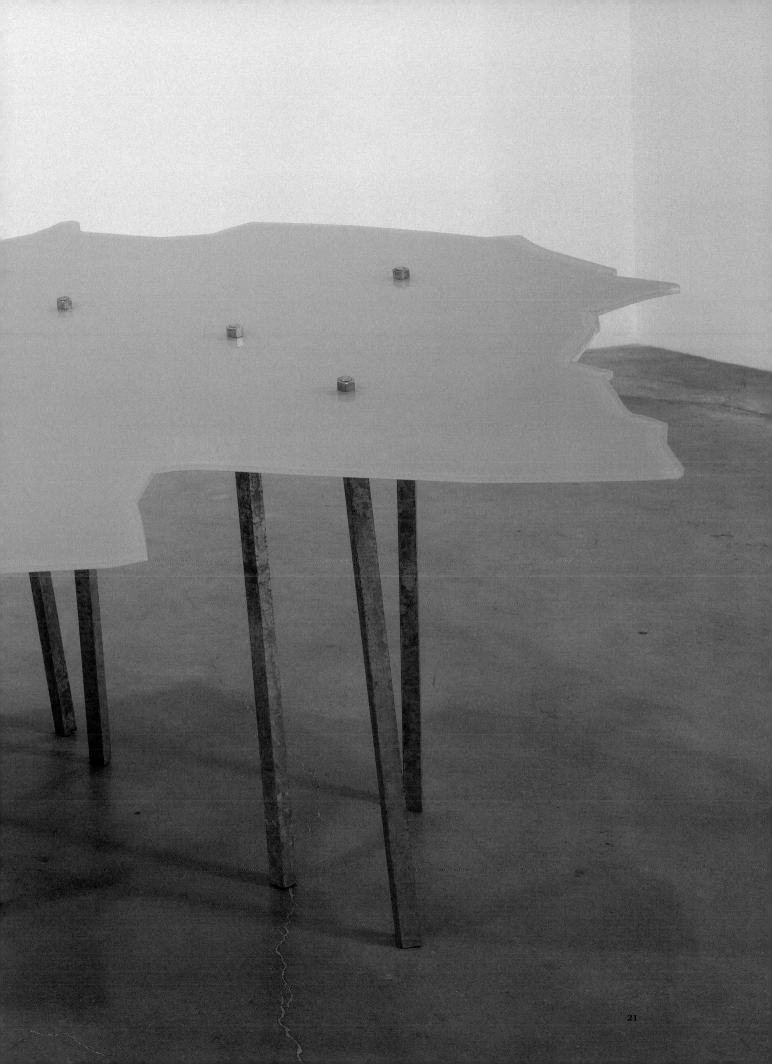

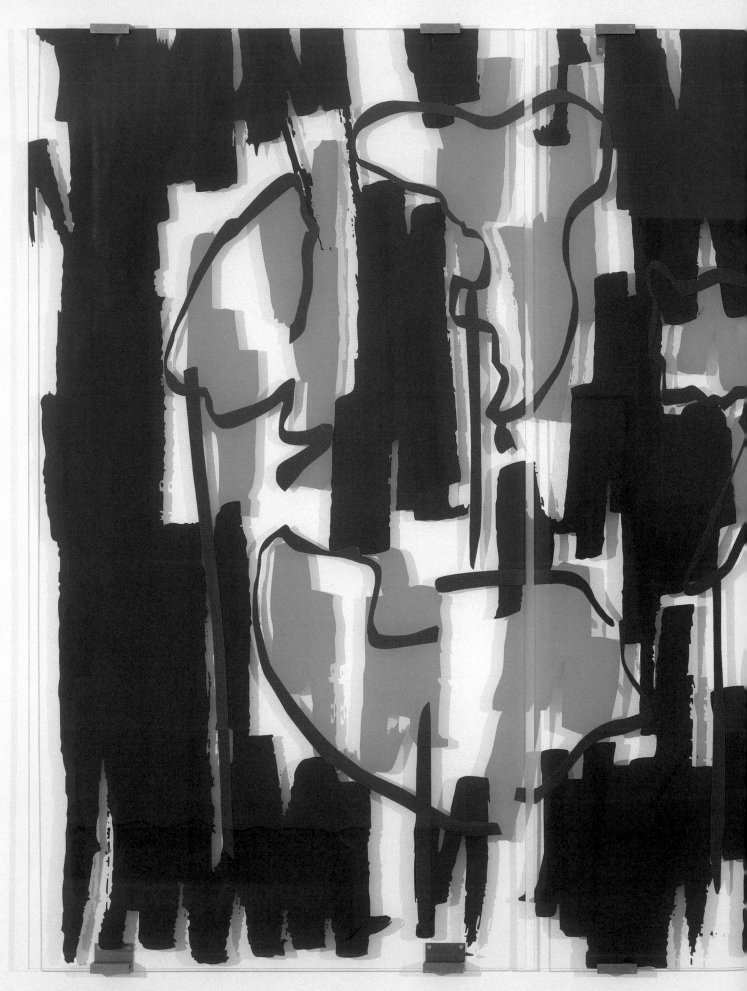

Panorama Flamants roses, 2002

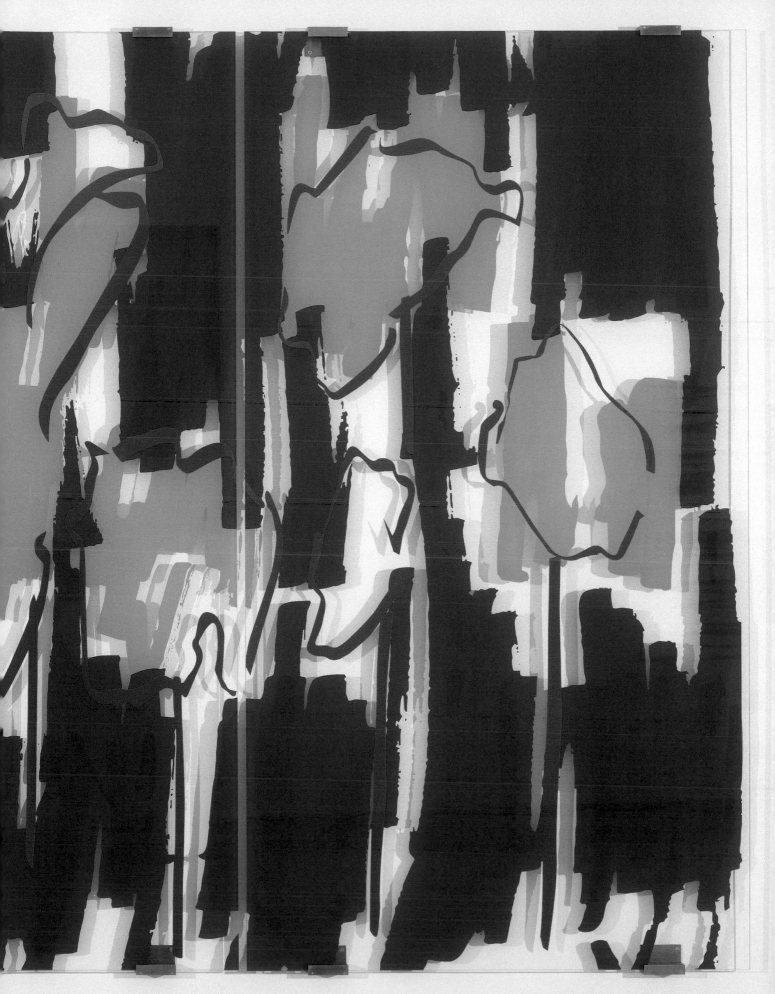

23

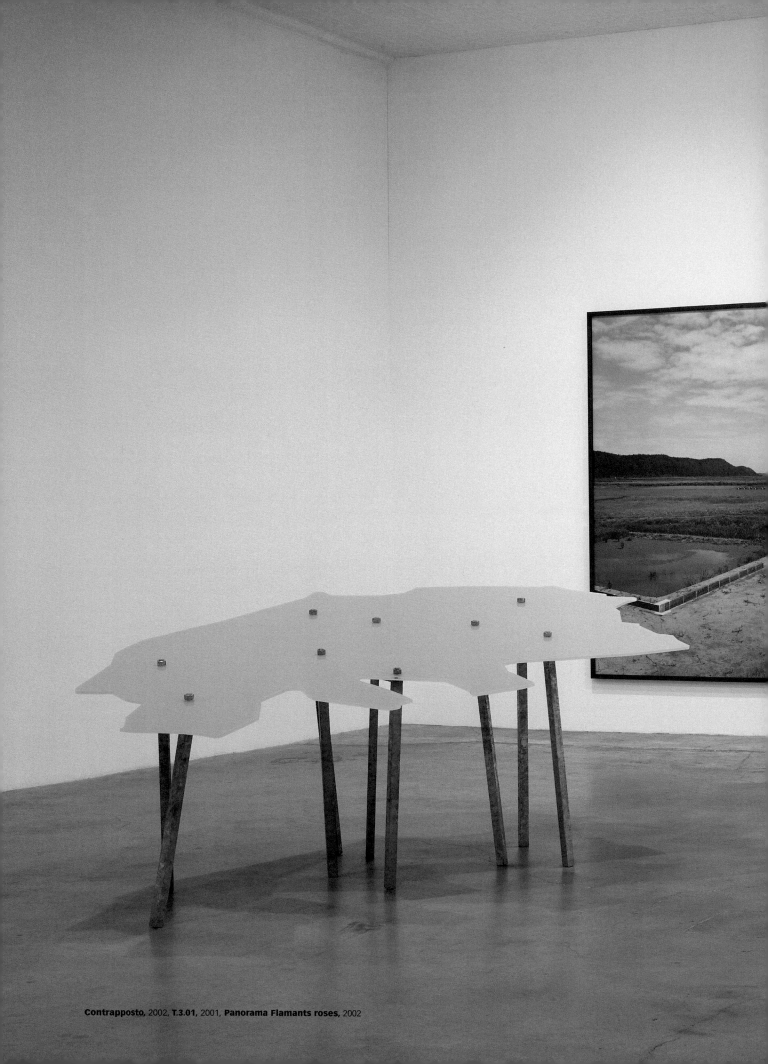

Contrapposto, 2002, **T.3.01,** 2001, **Panorama Flamants roses,** 2002

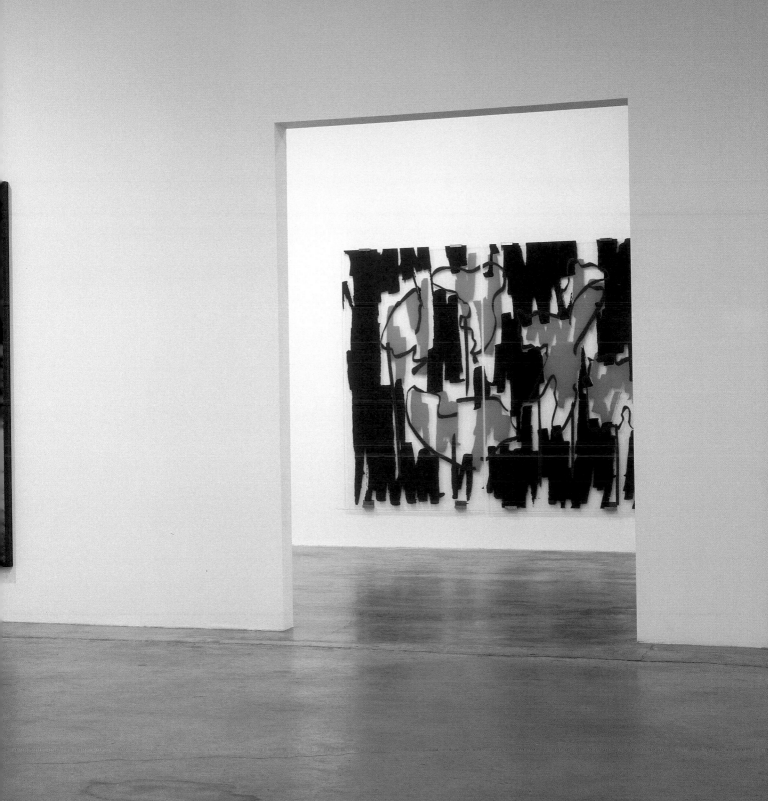

Dispersion I, 2002

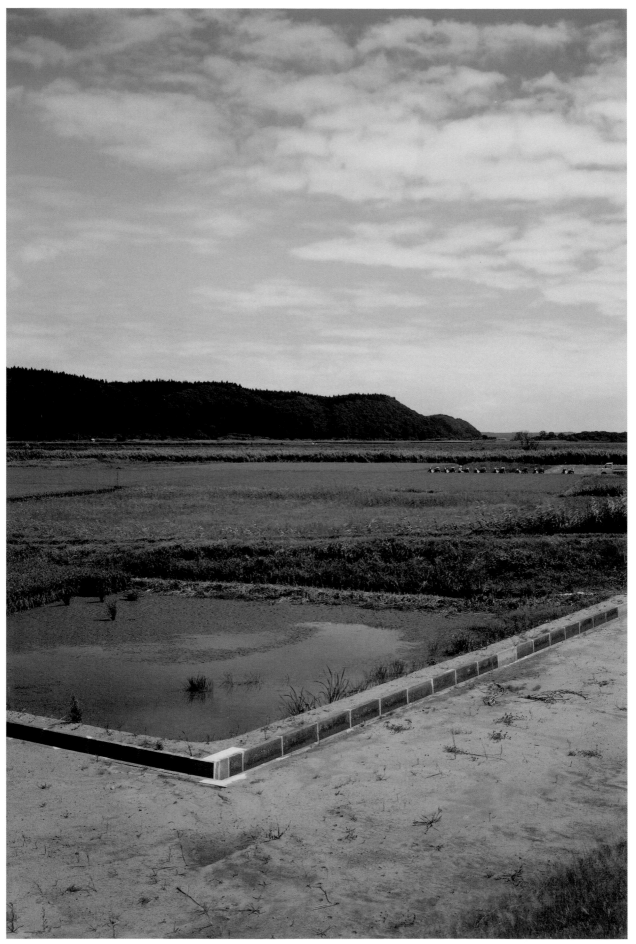

T.3.01, 2001

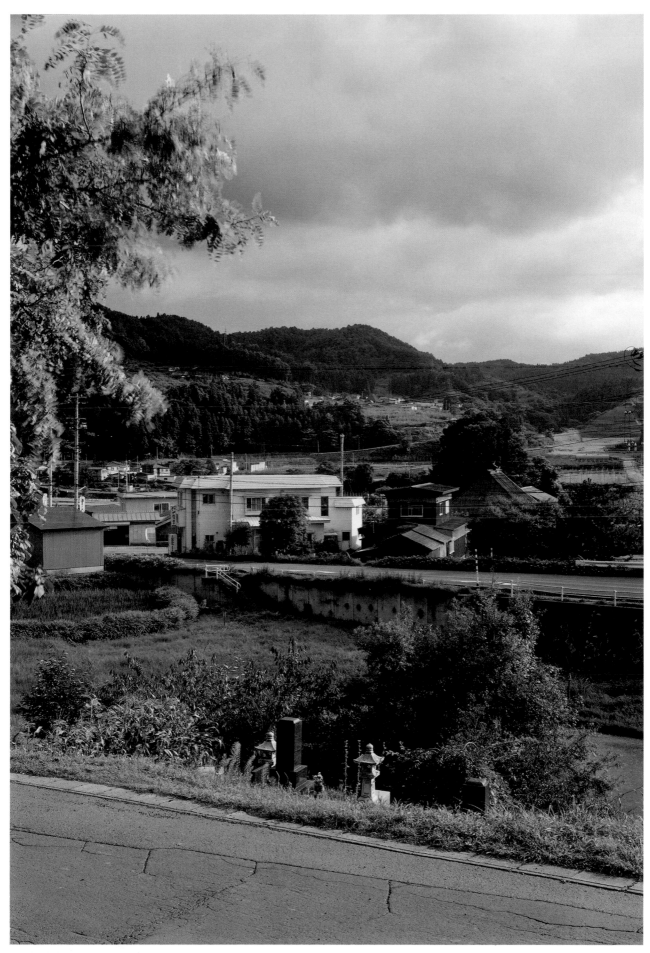

Manège, 2003

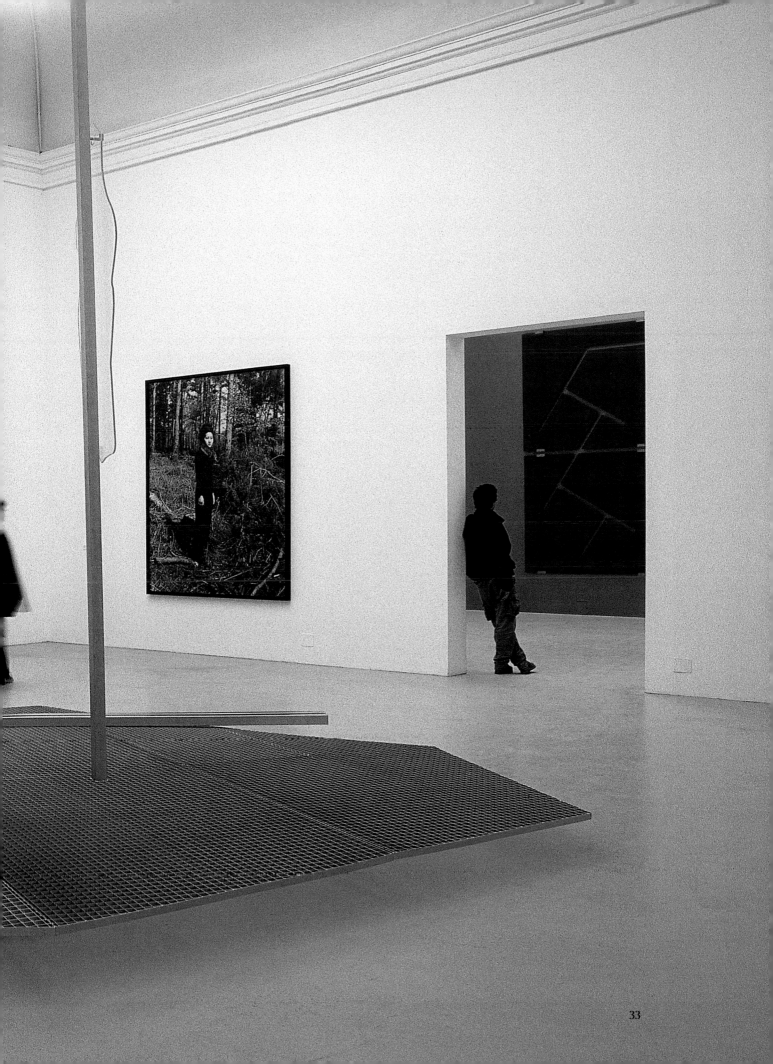

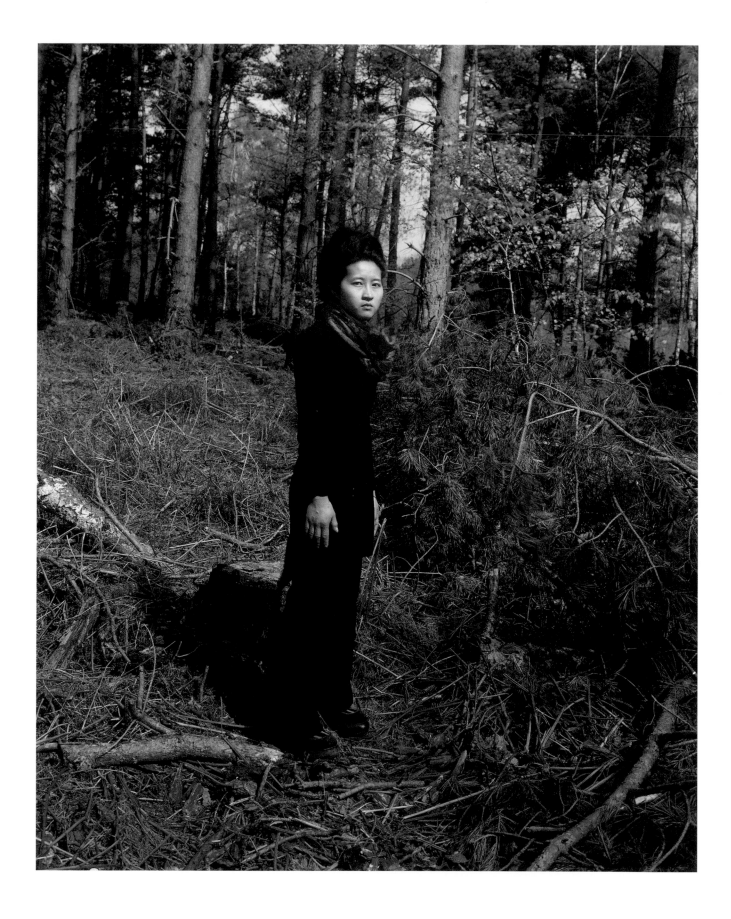

T.L.T.03, 2003

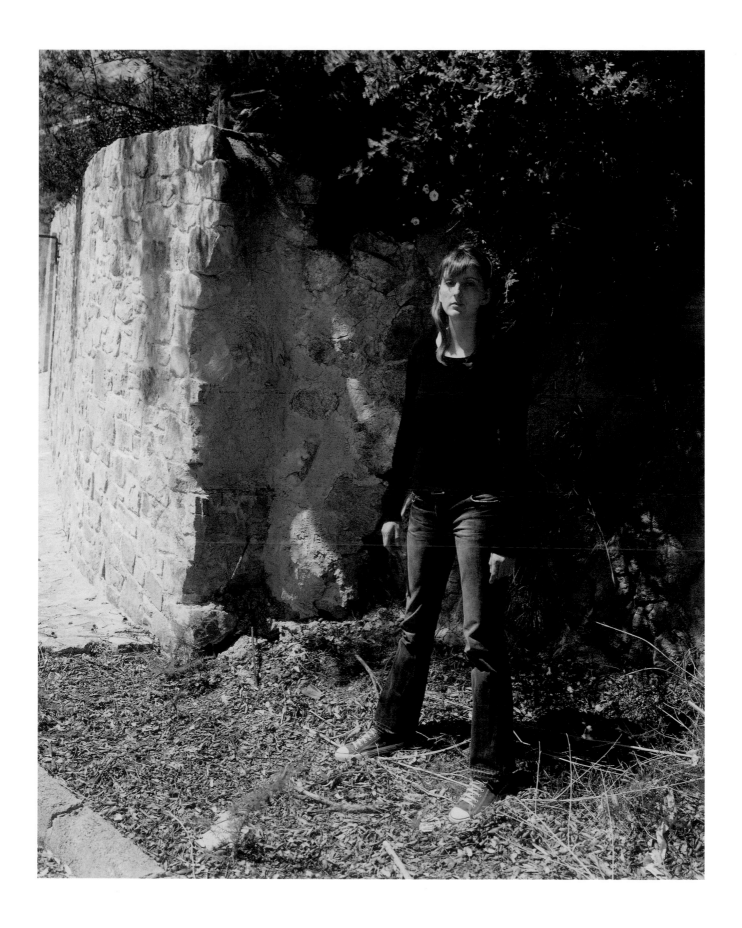

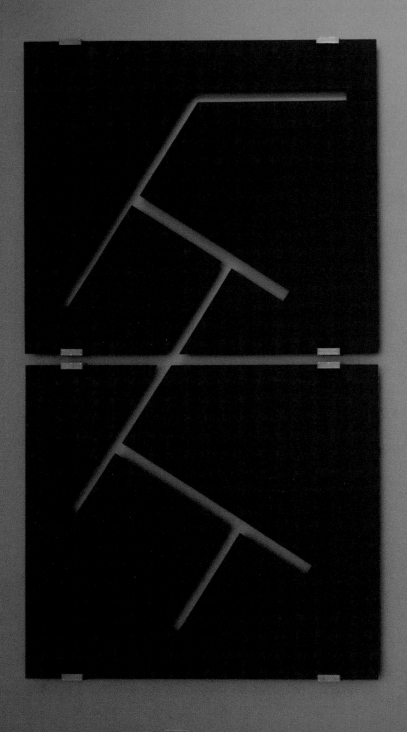

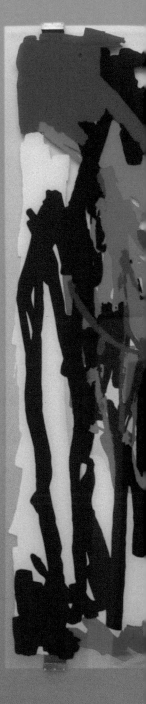

Panorama From here to there, 2003

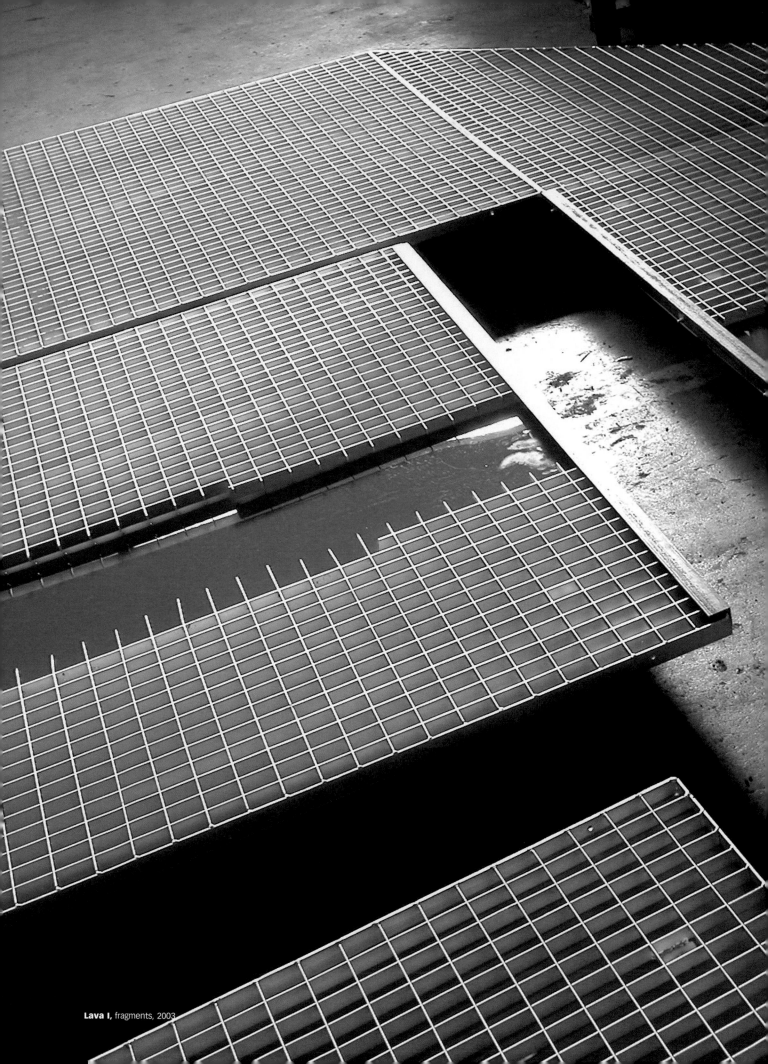

Lava I, fragments, 2003

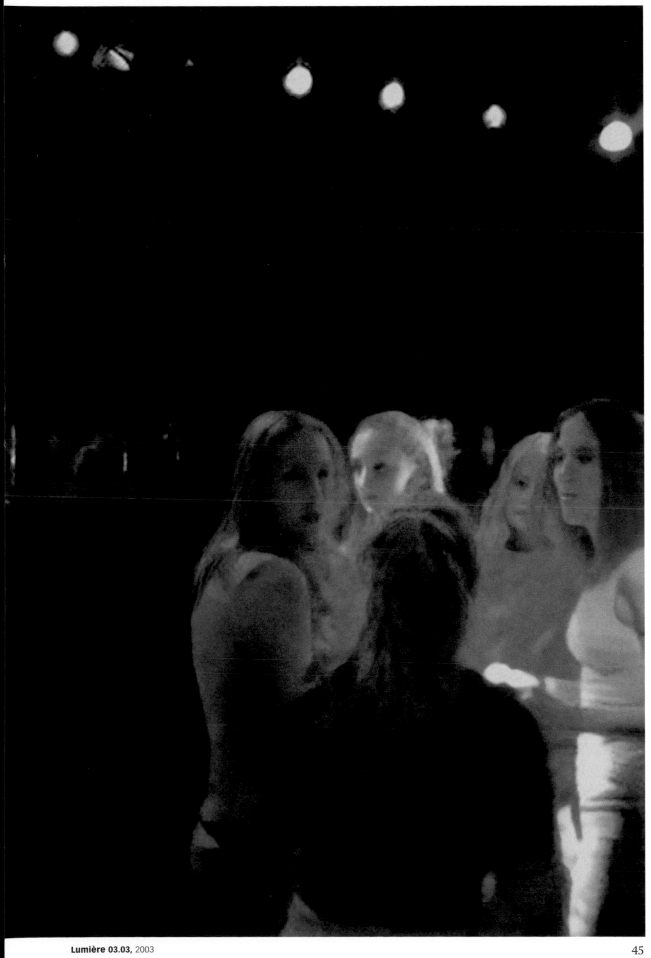

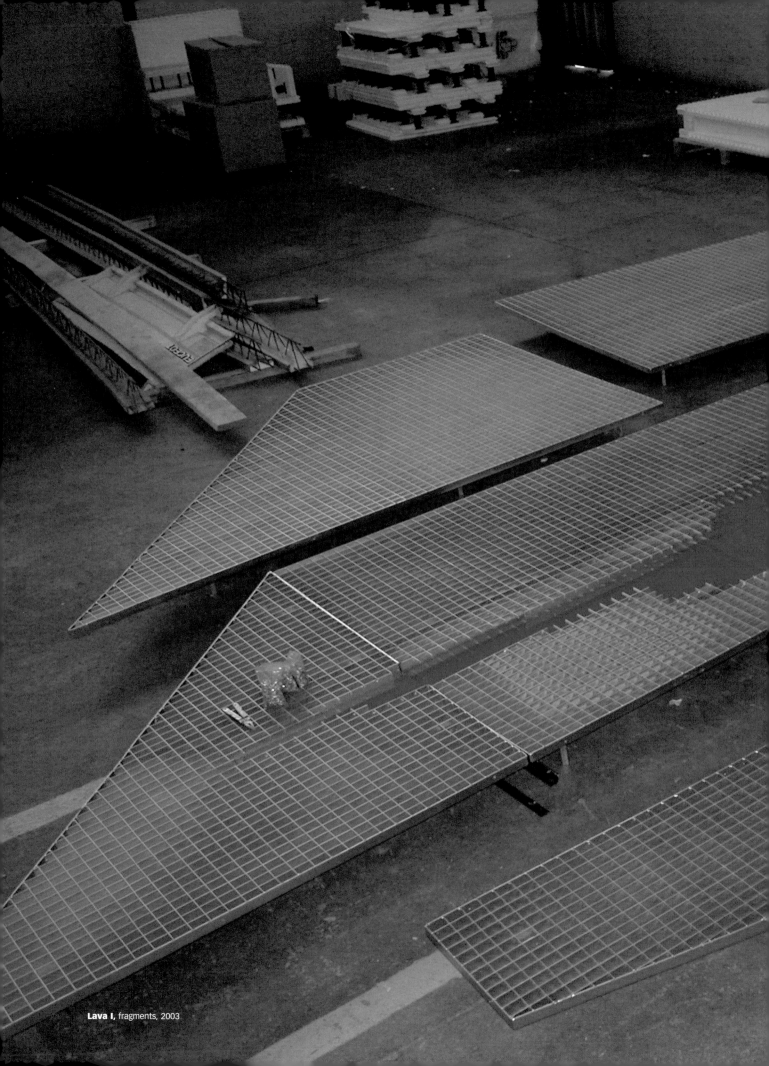

Lava I, fragments, 2003

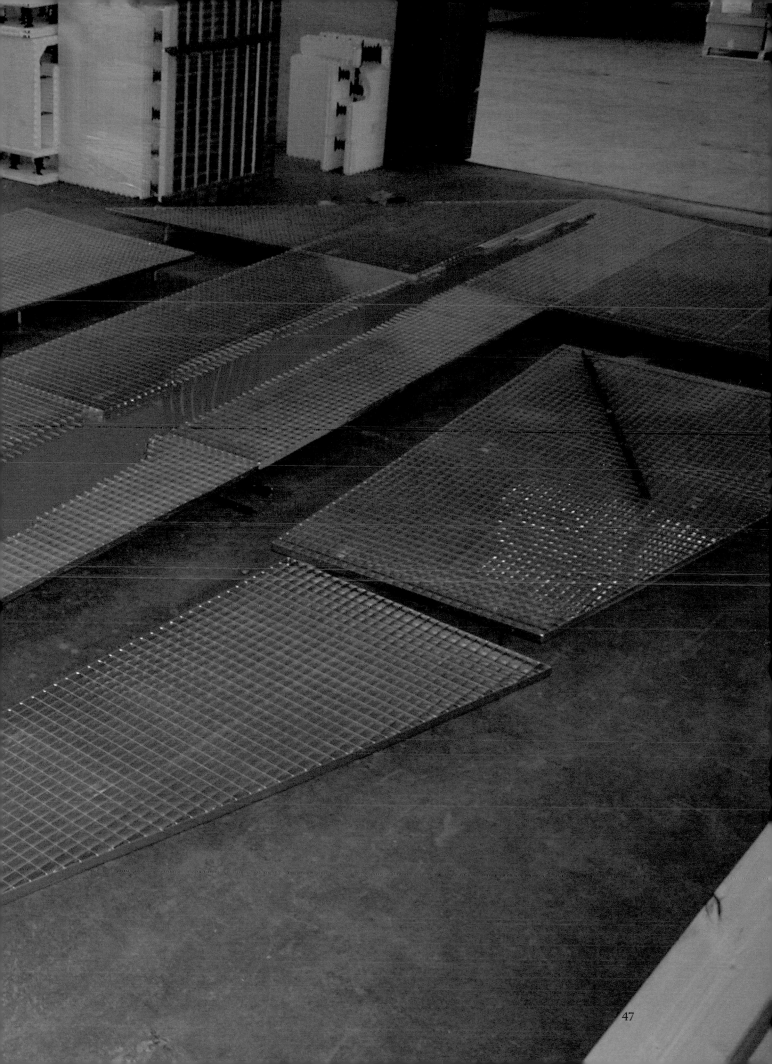

VAN EYCK.

Dessin préparatoire pour/Draft for **Trophée 3**, 2005

Dessin préparatoire pour/Draft for **Trophée 1,** 2005

1 _ Von Eyck

5

Dessin préparatoire pour/Draft for **Trophée 2,** 2005

Trophée 2, 2005

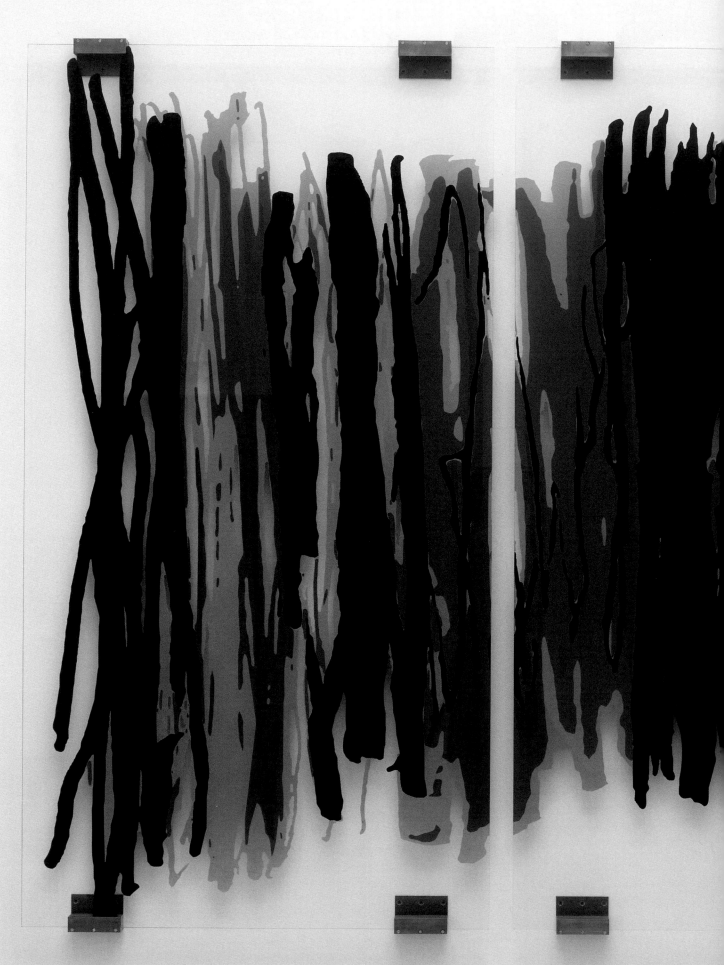

Panorama Entrelacs, 2003

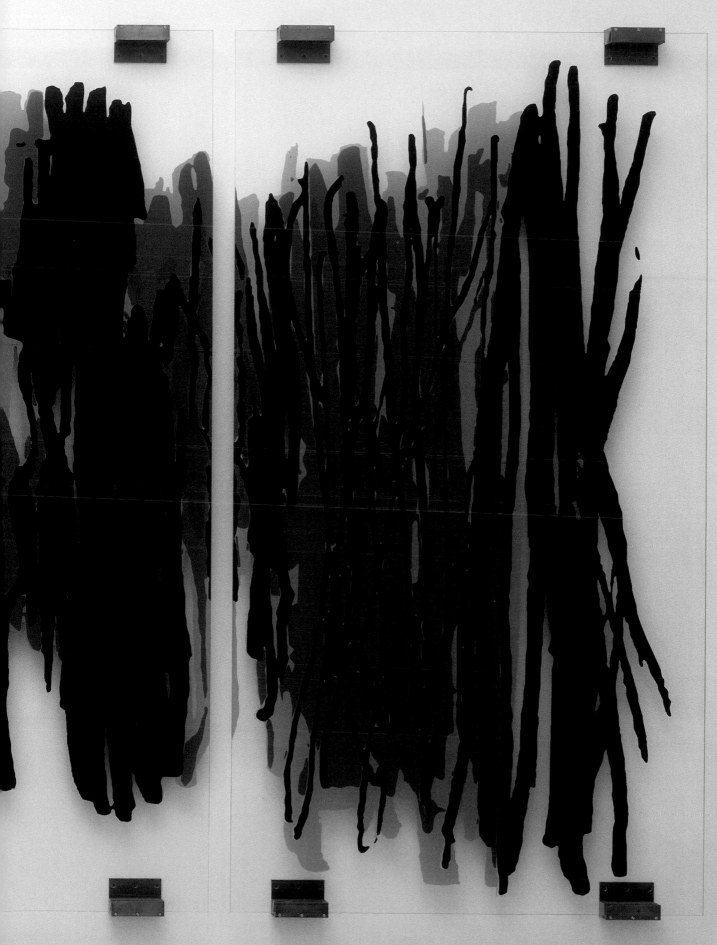

Manège, 2003

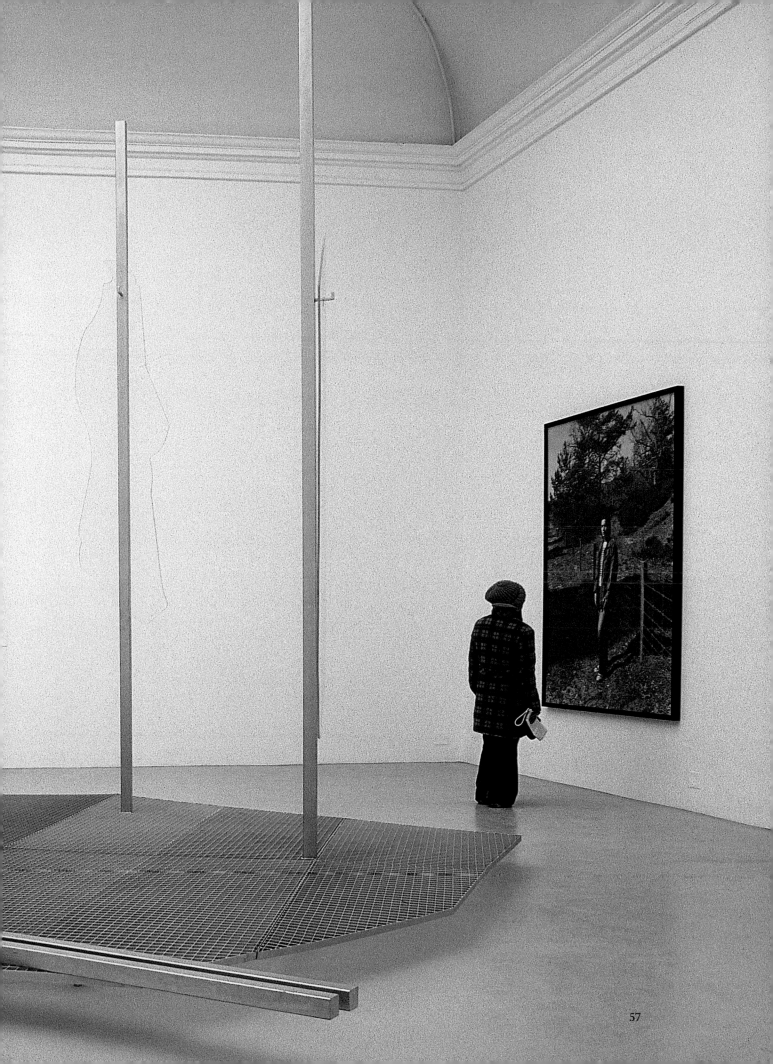

Panorama Perroquets, 2003

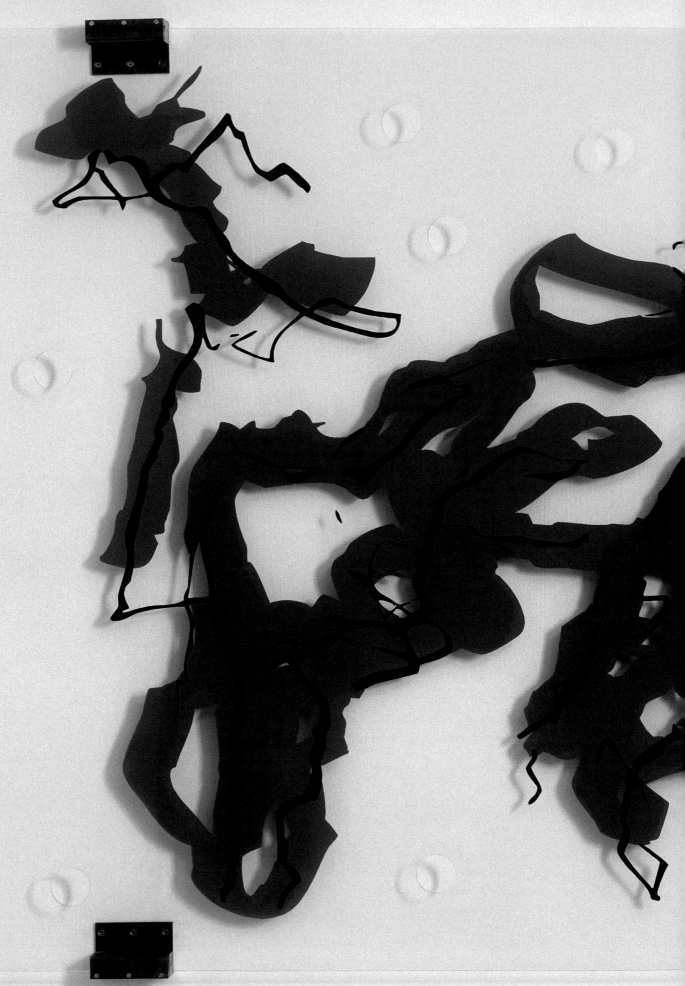

Panorama Pas de deux, 2004

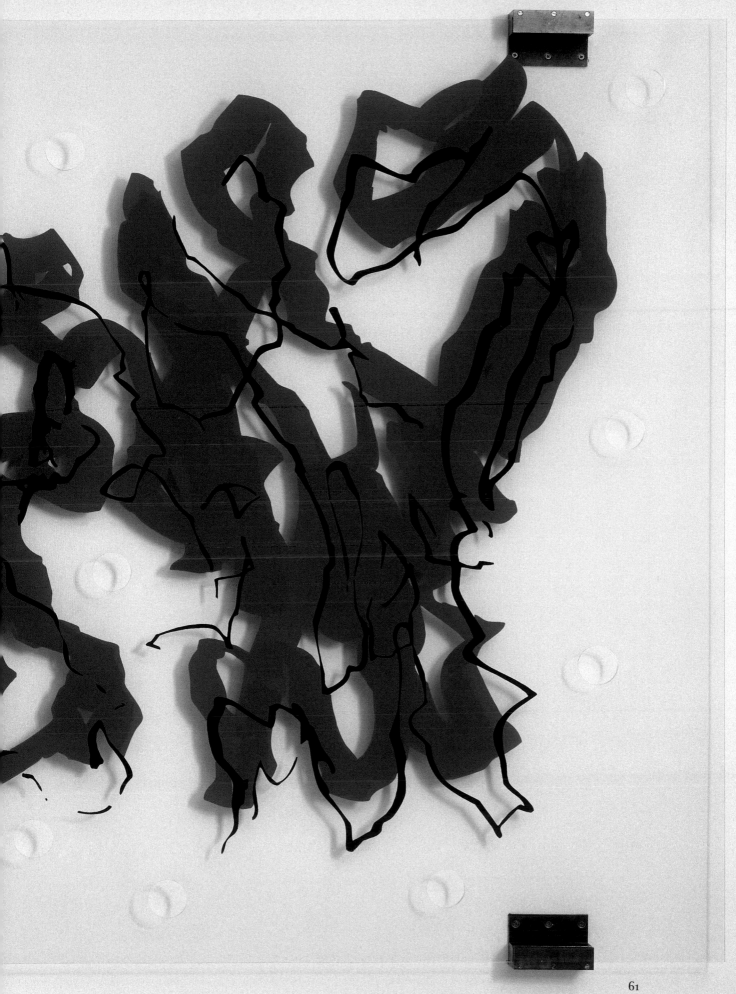

Panorama Beau fixe, 2004

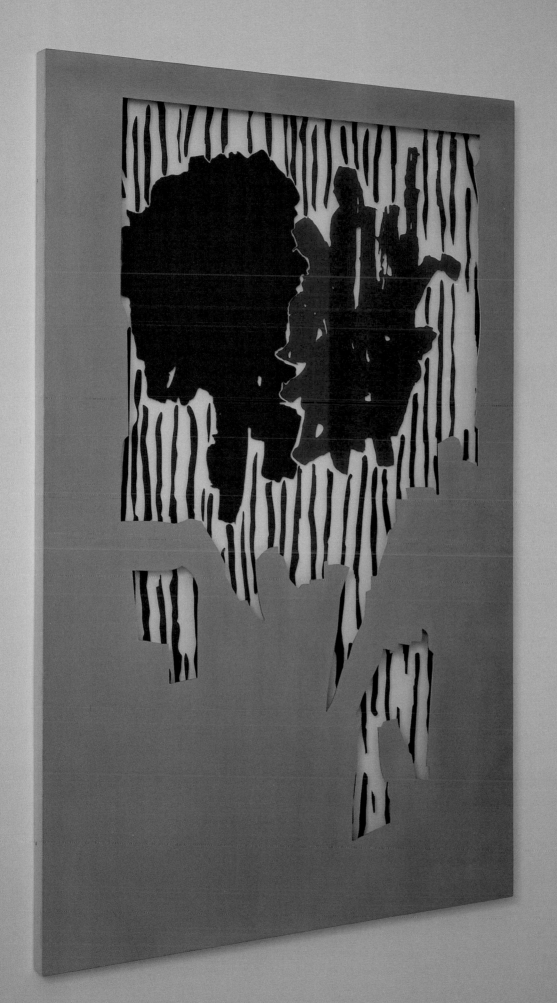

The Size of the Matter
Jacinto Lageira

T.26.80, 1980
Color photograph,
41 ¼ x 52 in. (1.03 x 1.3 m)

From the earliest photographic *Tableaux* (1978), down to the most recent works, Jean-Marc Bustamante's oeuvre—which might be characterized, in the perhaps hackneyed phrase, as one of "splendid isolation"—displays unbroken continuity. Not so much because of its conspicuous excessiveness (although the *Tableaux* have spawned a photographic style whose influence can be discerned here and there), as due to its capacity to show things, beings, and states whose principle of existence is their detachment; and to arouse in viewers a similar reaction of disengagement with respect to what they see before them. Simultaneously we feel an ease in encountering these objects, in admiring them for their color or simplicity, in attaining proximity to them, as if we were on familiar ground; yet we are still ready to be surprised by a particular form, and in no hurry to get to the bottom of certain compositions or to ascertain why certain installations create a resistance. This two-way flow explains why the "isolation" of these works is "splendid."

For Jean-Marc Bustamante, this oscillation was not the result of cutting himself off from the world of art, its history, and its challenges; it was an artistic investment and history. On the contrary, looked at in retrospect, the period of collaboration with Bernard Bazile (1983–87), using the name BazileBustamante—having been an apprentice in photography with Denis Brilhat (1972–73) and assistant to scriptwriter and photographer William Klein (1978–81)—indicates plastic links between image and object, and already a choice of media—photography and sculpture—that Bustamante continues to make his own. If one bears in mind works by the aforementioned artists, this was clearly a period of apprenticeship and interchange rather than one strictly of influence, as some commentators, occasionally at the expense of misconstruing the facts, have alleged. No doubt Bustamante, at the time a printer at Klein's, learned enormously by training "on the job" with one of the greatest contemporary photographers, but his own landscapes emerged as if from nowhere, even if one compares them with other contemporary photographs of the genre.

Certain features of the objects signed BazileBustamante seem to resonate on in the works of Bustamante solo. And yet, closer examination of the series of *Intérieurs* (1987) leaves one awestruck by the radical nature of the statement. Obviously, the concept of originality has been surpassed, and one can marshal a wealth of pertinent comparisons with a number of

bodies of work[1] that might have marked, if not Bustamante himself, then at least the period that witnessed the emergence of his earliest personal works. For the Zeitgeist is no epistemological pipe dream: it is an emanation of History from which individuals cannot escape.

To return, however, to this "splendid isolation"—it seems that Jean-Marc Bustamante produces "closed," difficult, idiosyncratic pieces; pieces that nobody else makes, hence their isolation. Nonetheless, he manages to touch the beholder, and that almost physically; to intrigue or astonish her so she is wrapped up, immersed in the piece as if she were part of it— hence the adjective "splendid." Yet, one would soon tire of an oeuvre dedicated body and soul to "splendor," while a corpus confined within "isolation" would end up as an irrelevance. Long after their realization, one remains forcibly struck by the plenitude of images in the *Tableaux*, by how everything is simultaneously delivered up and withdrawn. A superabundance of details vies with what one might be tempted to call vacuity. It is certainly not the first time in so-called landscape or semi-urban photography that such feelings are aroused by abandoned places, by waste or construction sites, where the traces of the human are in inverse proportion to the presence of human figures. But it is probably the first time that this status of the image and its reception in an idiom of

Intérieur I, 1988
Wood, metal, varnish,
7 ft. x 6 ft. x 12 in.
(210 x 180 x 30 cm)

withdrawal have been tackled in a project. A series of 138 photographs carried out between 1978 and 1982, they invariably measure 41 ¼ x 52 inches (1.03 x 1.3 m) unframed, were taken in the outskirts of Barcelona, almost always in the same level and brightness of illumination. They all show similar places shot from the same distance and, with rare exceptions, empty of inhabitants or any human presence.[2]

The series nature of the work, the identical framing, the homogeneous style, the objectifying view of things, naturally brings to mind other contemporary formulations—such as Bernd and Hilda Becher

T.34.80, 1980
Color photograph,
41 ¼ x 40 in. (1.03 x 1 m)

or Thomas Ruff—pertaining more or less to conceptual art, but such parallels are only pertinent with respect to external method. Because the result internally, i.e., what one finally sees in the photograph, is far removed, and even contradicts other styles that feature images devoid of all emotion. For all that, Jean-Marc Bustamante's works are not exactly charged with emotivity or pathos: no fury lurks beneath their calm surface. But they're

S.I.M.12.97, 1997
Color photograph,
16 x 24 in. (40 x 60 cm)

not cold either, without life or heart, so to speak. Still less can one speak here of harmonious regulation, of a sort of visual or iconographical equanimity.

Although Jean-Marc Bustamante does not belabor the point (for a craftsman and a rigorous artist like him it goes without saying), these shots with an 8 x 10-inch camera, possess a peculiar *feel* that conditions the object hanging on the wall in its frame, where the grain, the texture imparts a density that resurfaces in the *L.P.* series (though less in *Something Is Missing*): it's a question of the format and unicity of the object in the L.P. series—that is, of possible clues to their reading. Specifically, what can be the significance of a group of images in which the artist almost systematically endeavors to avoid showing the people who might live or move through the locations in question? Only eight photographs out of 138 in the *Tableaux* show individuals, generally in the background, and not a single one appears in the *L.P.*s carried out to date. Yet all around, including in apparently wild and wooded places, man's action, traces of his passage, are visible.

The untoward presence of man is indicated by dwellings, half-built houses, roads, electric cables streaming through the countryside, by mutilated tree trunks, by plantations, ports, cars, fences, and billboards, as well as by a host of other elements; more or less visible signs of the human monopolization of space—and as if removed, so to speak, entity by entity, from these selfsame images. The *Tableaux* convey neither desolation nor exaltation, yet they succeed in inducing, if occasionally only in retrospect,

L.P.II, 2000
Color photograph,
90 ¾ x 72 in. (2.27 x 1.8 m)

T.17.79, 1979
Color photograph,
41 ¼ x 40 in. (1.03 x 1 m)

a certain unease that relates to a physical absence of the human, conjoined to the joyful assertion of his absence from the image. Except for the series *Something Is Missing*, started in 1995, and *Amazones* (2003), it should also be noted that, since *Tableaux*, the founding principle of this procedure, all Jean-Marc Bustamante's photographs exploit the excess of a figuratively obliterated human presence. The final photograph utters a manifest paradox, insofar as traces and signs of the occupants of these places abound; an eye turns on them (the "shot," in point of fact), be it behind the camera or examining the photograph. Bustamante, however, places less stress on this paradox than on the ways in which human beings structure the space and time by which they demarcate and construct their territories.

The conditions and parameters referred to previously participate in the overall look of the photo, to which should be added the duration *of* the image, quite different from the ineluctable duration *in* the image—this moment of a particular space-time captured and conserved. Bustamante's photographs—and this remains true even of more recent examples—betray a peculiar manner of defining temporality and of transmitting it to a viewer who then appropriates it in accordance with the rhythm of an inner time.

T.C.R.03, 2003
Color photograph,
90 ¾ x 72 in.
(2.27 x 1.8 m)

In reality, one should speak of various layers of time apprehended paradoxically within one and the same space. Several slices of time seem to be compressed into a single image, a process that oddly enough allows viewers to recompose the instants, certain accelerations or decelerations.

There again, the exposure time, the atmosphere, the light at such and such an hour of the day all have a direct bearing on the image. But it's not that, or not only that, which communicates this particular duration to our perception . . . or, more exactly, which informs the duration of our

perception. In the same way that, within the image, man delimits a territory, Bustamante models the perception of the viewer, inevitably derived from the interplay between presence and absence inherent in photographs that at once approach and retreat from us, hollowing out, erasing the actual notions of image and perception.

Taken at a particular time and place, any photograph is necessarily a slice of space-time whose image it reconstitutes. Such physicochemical data are not nearly enough to enable one to make a good photograph—nor an artistically worthwhile photograph. Bustamante's photos, especially the series of *Tableaux*, sufficiently integrate these material data so they can be presented, as the artist himself puts it, as images "without qualities": bland, simple, uninteresting. Cacti and palms on the side of a hill, yawning quarries, gaping pipes, distant girders of buildings, heaps of breeze blocks and bricks, yet-to-be-completed middle-class villas, parched earth, dubious-looking footpaths—all this presents us with an image of a devalued landscape. Without interest. All the more since the quality of the photography and printing are of the highest order—far superior to that of the subjects depicted. The lack of "qualities," the commonplace, the banal reside in what is photographed, not in images that often only succeed in reinforcing their dull, nondescript appearance. Nevertheless, the image preserves something of the insipid uniformity of these semi-urban spaces, and one realizes that the subjects are not as anodyne as all that, and that certain characteristics seep into the image, be it only a soft light, the curious shapes of the architecture, a blue swimming pool, some lush-looking trees. This "without quality" would now reside rather in the photo, and not in the houses, roads, and undergrowth which, on paying them closer attention, seem to gain in individuality, in attractiveness. Certain landscapes even afford pleasure to the eye. The vacillation, hesitation, and indecisiveness these photographs demonstrate do not emerge simply by themselves; yet only this little exercise makes it possible to fleetingly recall their progress. Its demonstrates at least that the zone of passing time that appeared ungraspable, unnecessarily contrived even, settles into this supreme matter-of-factness rendered in magnificent and in simple photographs, which alert the eye to details of the greatest importance. Not because one actually spends time in such tergiversations, but because a certain duration of perception is required for the "without quality" of the image to leach into the real, and for the banality of actuality to impinge on the blandishments of the image.

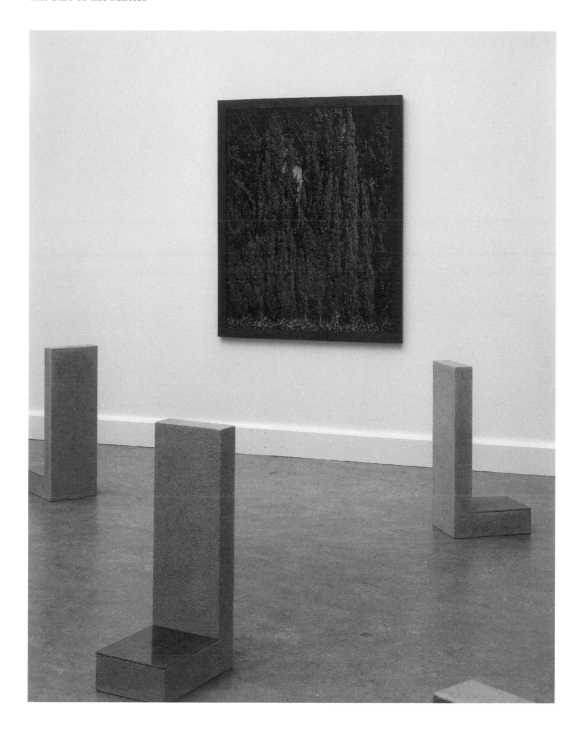

Stationnaire I (Stationary I),
1990, detail
Cement, resin, brass; sixteen elements,
each 32 ½ x 10 ¾ x 15 ½ in. (81 x 27 x 39 cm)
Color photographs; six elements,
each 60 x 48 in. (1.5 x 1.2 m)

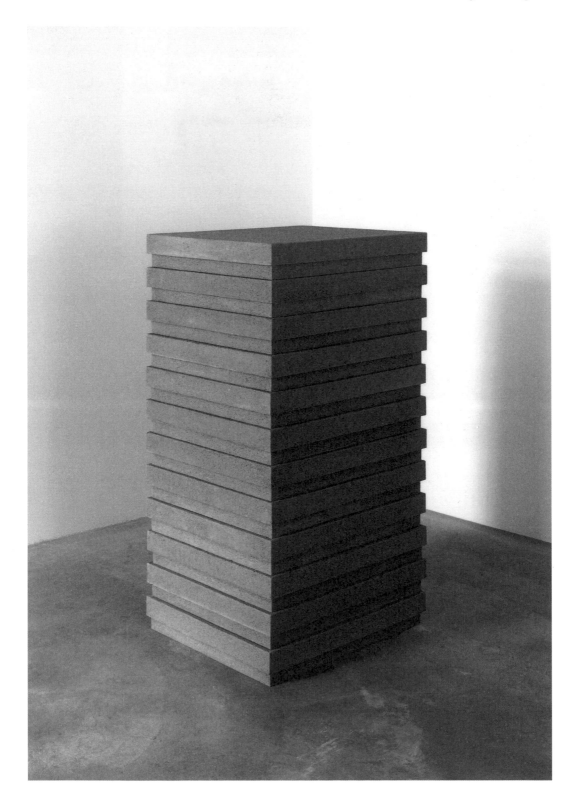

Stationnaire II (Stationary II),
1991
Color photographs, cement boxes,
resin, 48 x 22 ½ x 26 ½ in.
(120 x 56 x 66 cm)

A further aspect of this duration is the well-known "suspension of time"—above and beyond the inevitable fixation in the photograph. In the *Tableaux*, anyone familiar with the countries bordering the Mediterranean recalls that moment before everyday life has got going— or else that moment, that pause, intercalated into the flow of an already vagrant, unanchored temporality. Tools are downed, the roads empty, the swimming pools forsaken, houses seemingly mothballed. The

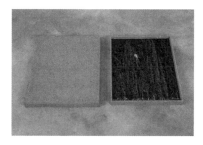

Stationnaire II (Stationary II),
1991
Color photographs, cement boxes,
resin; each box 26 ½ x 22 ½ x 3 ¼ in.
(66 x 56 x 8 cm)

photographer waits for a favorable moment; the image seems to mark time, just as we too wait in front of the image. A generalized stationary state. Substance, grain, heat, light, land, stones, and plants fuse to the point that the image seems more frozen than it freezes movement, than it halts the course of passing time.

With their imposing wooden frames, the *Tableaux* are like blocks of duration carved into the landscape, chunks of mineralized space-time one can carry about and hang up. The materiality, weight, and density of these images are corroborated in *Stationnaire I* and *Stationnaire II*, dating from many years later (1990 and 1991), where the photographs are related to three-dimensional elements or displayed in kinds of boxes placed on the ground with their lids to one side.

With respect to this shift from the vertical to the horizontal, as is the case again with the series of *Ouvertures* (1993–96), a phenomenon should be stressed that often passes unnoticed, as it depends, once again, on the infinitesimal transitions between space and time in the instant of our perception. Time in these photographs is not the same when perceived from a standing position as when perceived looking downward. The moment the observation takes place, our body adapts so well to the two modes of perception that the difference is erased—or, more precisely, slowed down. Curious though this may seem, to be *stationed* standing in front of a landscape photograph does not occupy the same time and same

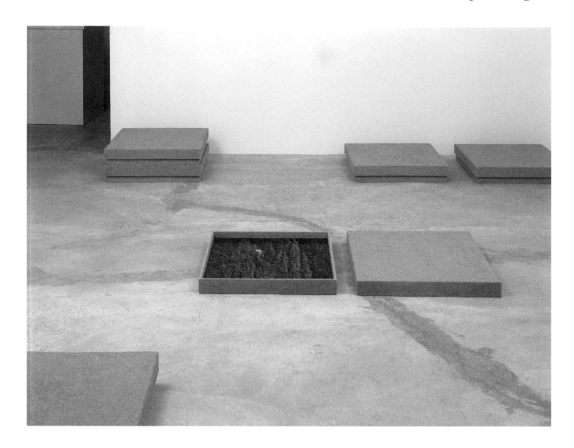

Stationnaire II (Stationary II), 1991
Color photographs, cement boxes,
resin; each box 26 ½ x 22 ½ x 3 ¼ in.
(66 x 56 x 8 cm)

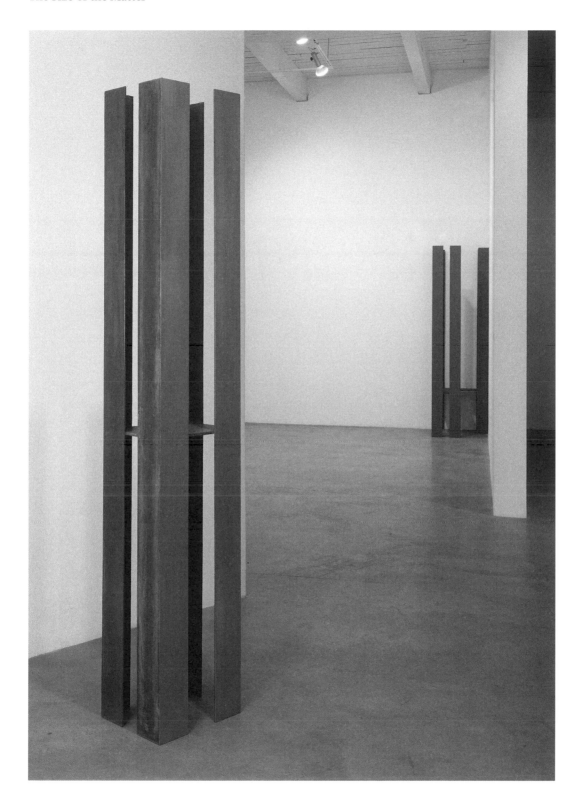

**Paysage droit debout (Landscape
Straight Standing)**, 1993
Steel, galvanized paint,
87 ½ x 14 ¾ x 12 ½ in. (219 x 37 x 31 cm)

space as the act of leaning slightly over a low table to examine an image lying on it. The parameters of this relative conditioning are constituted chiefly by cultural habits and practices dominated by the visual for millennia. Yet, simply by displacing images and bodies, Bustamante reminds us of the physicality of things: the substance in the subject of the image, the substance of the photograph itself, the substance of the table—the flesh of our body. The *Tableaux* foreshadow and condense many features that recur in later works, like branches sprouting from a single trunk.

Thus, *Stationnaire I* and *II* attempt to seize in different ways the fleeting but perceptible moment where things seem to stop, to freeze, while a piece like *Paysage (droit debout)* places horizontal images upright. The title is not the only clue to understanding the piece, since the latter, just like the one entitled *Paysage (droit devant)*, is a vertical, abstract sculpture that marks our upright *station* in front of it (*droit devant*), ensuring that, after directing one's glance at a landscape—generally taken in horizontally, circularly—it returns from the ground to a vanishing point at eye level. In their turn, other works (*Paysage IX, X, XII*), cutout,

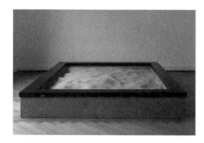

Bac à sable I (Sandbox I), 1990
Cement, wood, sand,
92 ½ x 73 x 11 ¼ in.
(231.5 x 182.5 x 28 cm)

notched reliefs coated with minium paint and displayed hung like paintings or photographs, bear—as if this time the cypresses in *Stationnaire* II had been straightened—the heading, "landscape." Since nothing figurative is visible, and, more specifically, no element reminiscent of anything we might traditionally consider as a "landscape," the genre is surely applied solely to the surface material, to the support and its format, to the perceptual situation it entails. Stranger still, the structures in cement and relating to a specific piece of architecture—as presented in the house built by Mies van der Rohe for Hermann Lange—are also called "Landscape." These then revert to a physical context that melds verticality and horizontality, the visible aspect of a genre that acquires consistency only in our imagination or within a concept.

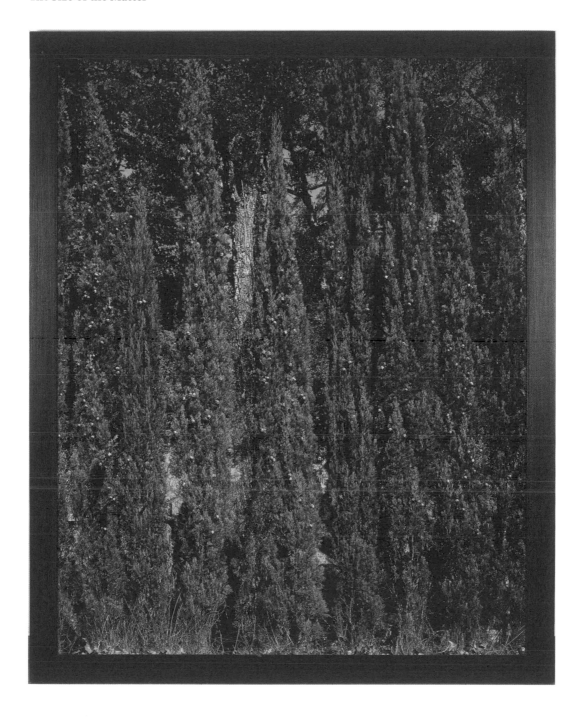

T.126.91, 1991
Color photograph,
55 ¼ x 44 ½ in. (1.38 x 1.11 m)

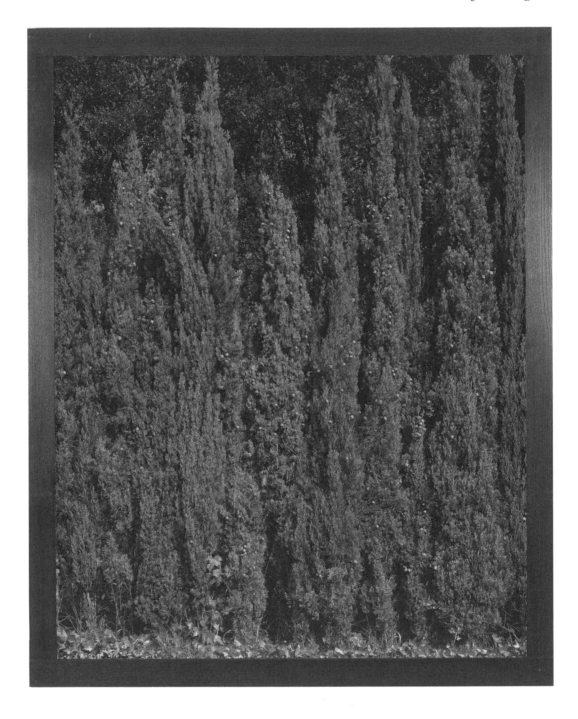

T.133.91, 1991
Color photograph,
55 ¼ x 44 ½ in. (1.38 x 1.11 m)

Unless one examines in greater detail the effect of the subject matter and materials from the photographs in the *Tableaux* on the subject matter and materials of the sculptures, the mere denomination might seem an expedient or, at the very least, a sort of poetic license. For what is photographic about a sculpture and what's sculptural in a photograph?

The initial impression is that, be it literally or metaphorically, the stretches of land, the terrains depicted in the photographs, the breeze-blocks, the concrete girders, the houses, the vegetation, and other elements, turn into the bricks, cement, wood, and vegetal paper subsequently integrated into the sculptures. This material transposition that resurfaces in the materials and arrangements of the objects or photographs is compounded by the memory of the duration of the images, the recall of the image space—a space-time event that exists solely in the images and in the viewer; or, more exactly, between the viewer and the images, between the viewer and the sculptures.

All things considered, this relationship would be relatively clear-cut, even self-evident, were it not for the delays and decelerations suggested by

Paysage droit devant (Landscape Straight Front), 1993
Steel, minium paint,
88 x 57 ½ x 16 ¾ in.
(220 x 144 x 42 cm)

the materials, together with the abrupt transformations, sudden faults, disconnections, disarticulations. Jean-Marc Bustamante's work is a universe of continual gestation and formation between reality and material. It can be approached as it unfolds chronologically, yet, by observing the passage from duration to material, from material to space, from place to materials, from geology to human construction, a very different image of its force field is uncovered. It would be inaccurate and untenable to explain these changes solely by way of the idea that everything is in everything.

To an extent, admittedly, the materials used for the sculptures preexist in the photographs. Certain forms are quoted from directly, such as the sculpture *Verre bleu* [Blue Glass] (1987), whose shape is

identical to that of the swimming pool in *Tableau no. 42* (1981), or *Bac à sable* [Sandbox] (1990), the transposition or, rather, the almost literal transfer of several kilos of earth into a huge wooden photograph frame. The *Arbres de Noël* [Christmas Trees] (1994–96) seem to have tumbled out of a fragment of a *Tableau*—including the plinth that reappears unaltered in the construction—or this photograph from the series of *Cyprès* [Cypresses]. Yet can the manner in which images and objects are generated and created be explained solely by such relocations? Moreover, is such a vocabulary rooted in the organicity of the oeuvres fully adequate?

It is tempting to divide Bustamante's sculptural corpus formally into geometrical and organic, since the cutout forms are clearly delimited by the artist, who only mixes the two genres very rarely, with the exceptions of the *Panoramas*, and of more recent works, such as the *Mesa*. Hence, *Les origines*, *Les Autres* [The Others], *Les Continents*, *Dispersion*, or again *Sans titre (triptyque)* [Untitled (Triptych)], 1993, present a dramatic contrast with, for instance, the three *Sites*, the series of the *Paysages minium*, *Paysage zinc*, *Aller-retour II* [Back and Forth II], and with the pieces in installation at the Haus Lange, Krefeld.

A further distinction could of course be made between the photographs—which can only be a physicomechanical trace of beings and organic elements (inhabitants, vegetation, water, soil)—and the sculptures, which are organic only in appearance, as the result of mere cultural conventions predicated on the history of statuary. The links between the works listed above should preclude overhasty demarcation, however. That would be an obstacle to the comprehension of his project overall and leads in the main—and this is still frequently the case among commentators supposedly accustomed to Bustamante's work— to the corpus being dismantled, and, ultimately, dismembered. This need for organicity and for the organic is due principally to a drive to uncover the living, or whatever represents or presents life, through an artistic practice that appears obstinately to reject any image or form redolent of it. After all, even works like *Arbres de Noël*, *Les Origines*, or *Leda*, with their echoes of trees, leaves, or a liquid element, are only metal or glass. Nothing could be less organic. This dearth of life, of the living, is, however, no studiedly calculated coldness, no rejection of the society of men and their images, no eradication of anthropomorphic

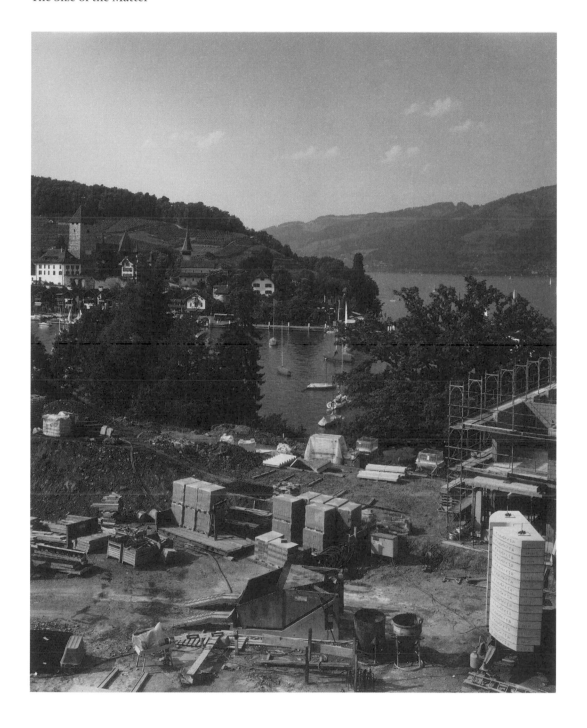

L.P.IV, 2000
Color photograph,
90 ¾ x 72 in. (2.27 x 1.8 m)

residue. Rather, it is a way of being in the world. Without denying formal and plastic links to other practices and trends that precede or are contemporary with Bustamante's oeuvre, this manner of existing, of forging relationships between viewers and his works is much more closely connected to a real commitment to detachment. It's not a question of simply taking a photograph of a space bereft of all occupants, of manufacturing an object reminiscent of a bed or cupboard but divorced from its function, of integrating the viewer's body the better to keep her at a distance in some challenging artistic gesture or hieratic attitude for which she has no need. The purpose is to create forms that show us how to think and feel differently, that make us exist in a new way after experiencing them.

Paysage XA, 1990
Steel, cement, resin,
minium paint,
72 x 35 ¼ x 14 ½ in.
(180 x 88 x 36 cm)

And experience with Bustamante's work does teach us that we are caught as much in plenitude as in rarefaction, in excess as in nothingness, in fullness as in emptiness. Such oppositions might sound overschematic, smacking even of that one-size-fits-all reference to Far Eastern thought in which opposites are all complementary, where everything is reabsorbed into an ever-fruitful Nothing. Yet, Bustamante's oeuvre is indeed made up of simultaneous giving and withdrawing, simultaneous presentation and obliteration. The process brings to mind Michel Leiris's remark after a journey to China in which he underlined a fundamental component of Taoist thought: "In preference to what is, emphasize *what is not.*"[3] For thirty years now, Jean-Marc Bustamante's whole oeuvre has been informed by this dilemma, which consists of toying with this visual oxymoron, so as to show, detail, circumscribe, and offer up to our perceptive faculties "what is not." It has no truck with dichotomies or scissions—such as those between the organic and the geometric, between photography and sculpture, between the abstract and the figurative, between presence and absence—because these terms are inconceivable separately and are continuously being interlinked.

Arbres de Noël
(Christmas Trees), 1994–96
Steel, paint, varnish, concrete base;
21 elements, each 92 x 19 ¼ x ½ in.
(230 x 48 x 1 cm)
Base: 6 x 24 x 8 in. (15 x 60 x 20 cm)

Following double page
Site III, 1992
Steel, minium paint, wax,
15 ft. x 11 ft. x 7 ¼ in. (450 x 330 x 18 cm)

One of the strengths of his approach is to have profoundly reconfigured these concepts in order to purge them of negative and/or exclusive characteristics. Mired as we are in a Greco-Latin mind-set and in the venerable tradition of the system of mimetic representation, it is no easy task for us to think of "what is not," otherwise than through withdrawal, disappearance, nullity, emptiness, and nothingness—terms that are all figures for the negation of being.

Writings by abstract painters such as Kandinsky, Malevich, Mondrian, or Ad Reinhardt, among others, attest to the exclusive opposition between being and non-being, and describe their respective natures solely through oppositions worthy of that Negative Theology, which sought to explain being by what it is not, and non-being by what it cannot be. To truly get to grips with Jean-Marc Bustamante's project, which is a human as well as an artistic one, we have to transform our models, our conceptions, our modes of perception. This, though, is something our ontological-theological predispositions and the subject/object relationship—with everything they entail in terms of exclusions, divisions, and ultimate foundations, of quests for essence and truth; in short, everything concerned with the burdensome metaphysical tradition in which

Origines IV, **V**, and **VI**, 1992
Metal, lacquer,
71 ¼ x 59 ¼ in. (1.78 x 1.48 m)
70 ¾ x 57 ¼ in. (1.77 x 1.43 m), and
68 x 61 ½ in. (1.7 x 1.54 m)

Intérieur III, 1988
Metal, Formica,
48 x 32 x 18 in. (120 x 80 x 45 cm)

we still ensnared (and this in spite of profitable contributions from the phenomenological approach as championed by Jean-Paul Sartre and Maurice Merleau-Ponty)—will simply not permit us to do.

To clarify the authentic transformation that Bustamante's work proposes, we shall have to adopt a different model of reflection, a different intellectual and perceptual viewpoint, and occupy for a moment a zone in which things are and at the same time are not, where the "there is" is also a "there is not," like that developed over two thousand years in Chinese treatises on painting. If we concede that Bustamante does not transpose this form of thought over into his own work (he is unlikely to be very

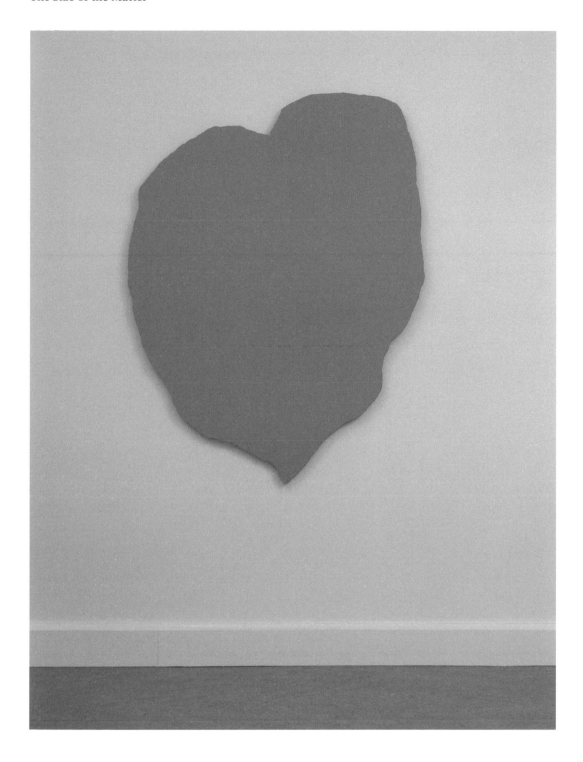

Origines, 1992
Steel, lacquer, 71 ¼ x 64 in.
(1.78 x 1.6 m)

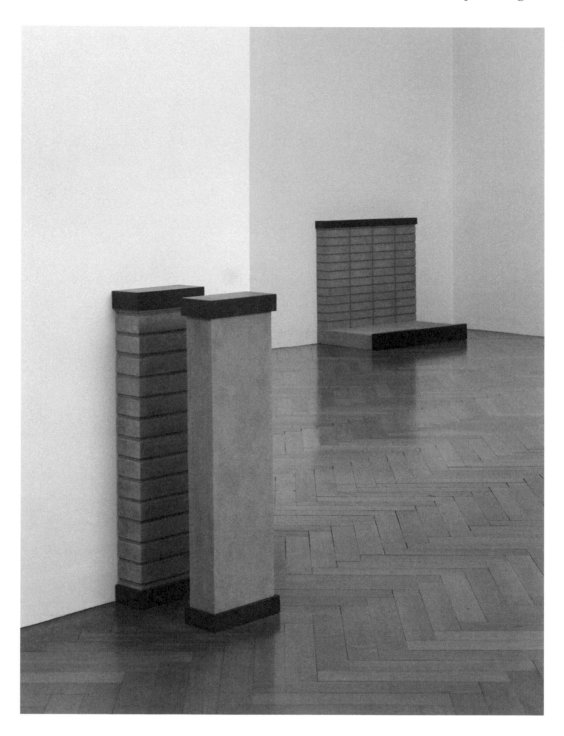

Aller Retour II
(Back and Forth II), 1990
Cement, wood; each element
29 x 38 x 12 in. (72.5 x 95 x 30 cm)

Aller Retour I (Back and Forth I), 1990
Cement, wood,
37 ½ x 42 x 24 ¾ in. (93.5 x 105 x 62 cm)

familiar with it), the similarities between the concerns of the two endeavors are nonetheless striking, down to certain remarks made by the artist[4] himself—starting with the fundamental idea that showing "what is not" is as much a form of plenitude and completion as showing "what is."

In his essay devoted to scholarly Chinese writings on painting, *La grande image n'a pas de forme*,[5] François Jullien is careful not to treat Chinese conceptions merely as a foil to Western aesthetic thought.

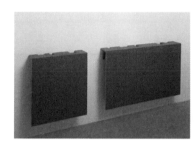

**Paysage XIX
(Landscape XIX)**, 1990
Steel, minium paint
Left: 28 ½ x 24 ¾ x 6 ½ in.
(71 x 62 x 16 cm)
Right: 28 ½ x 46 ¾ x 6 ½ in.
(71 x 117 x 16 cm)

Far from assigning to it the all-too-customary role of the Other, Jullien demonstrates how its profound insights can teach us a great deal about ourselves. Here, more modestly, it will serve to bring out certain facets of Bustamante's work, not by baldly importing its concepts wholesale (which, by the way, is not a particularly viable operation for the majority of contemporary artists), but instead by revealing the inner mechanisms of his work, and so fostering a long-overdue sea change in our aesthetic attitudes.

As in traditional Chinese painting, Bustamante strove and still strives to withdraw, erase, or—put more simply—to avoid showing certain stages, situations, or people, exactly where one might be sure of finding them—in the *Tableaux, Intérieurs, Lumières, L.P.*, but also in *Site, Bac à Sable*, and even, in a very different way, in the *Panoramas*. With respect to Bustamante, care should be taken not to take these terms in their traditional meaning as denoting a "being-less," since for him it is crucial to present, even occasionally to highlight, a *different state* of things and beings—a state that in no way implies total erasure. The idea is to depict the instant of a general process where, as in Chinese examples, "to paint the indistinctness of transition, [painting] has to abandon its powers of description and injunction of signs: instead of allowing itself to become monopolized by objects, it renders their obliteration; instead of offering them up to the gaze, it deflects them towards their reabsorption. . . .

By painting *between* the 'there is' and the 'there isn't,' he [the painter] allows access, not to what 'things' might be in themselves—the *en-soi*, the essence, but to the process, the continual transition, which ceaselessly brings forth, only to conceal."[6]

To understand Bustamante's works by way of units of measurement that record whether they contain more or less being, more or less presence or absence, is to distort his aim, a project quite unlike that espoused by those many artists, abstract or no, who wallow in the mystical, the spiritual, and who, with this purpose in mind, undervalue or evacuate the material and psychical realities. This is all the more true since all Bustamante's pieces present the visible, the perceptible, the material to

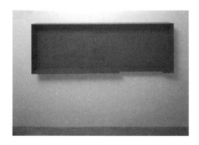

Paysage XX,
(Landscape XX), 1990
Steel, buffed minium paint, wax,
28 ½ x 80 ¾ x 6 ½ in.
(71 x 202 x 16.5 cm)

excess. Playing subtly on potential shades in the notion of "being," the superabundance of matter and detail—or of weight and density—recedes, or is bracketed off, to allow the supervention of something quite other than what one can see.

In the last analysis, this is an old artistic trick, but one mastered only by the greatest exponents: too much appearance undermines the reality one wishes to present, while not enough leads to platitude. This too Chinese scholars appreciated, witness Tang Ziqhi: "'If one accords priority to the manifest without concealment, [the result] is weak and superficial'; but if one 'conceals' without really 'knowing how to conceal,' interest drains just as fatally."[7] The second part of the first of these comments chimes in with one of the recurring features of Bustamante's oeuvre with regard to the temporal delimitation of the works and the viewer, by stressing the transient, the endless flux of things and beings, the ephemeral—that which arises only to vanish—without making one essential to the detriment of the other, however. Presence and absence are co-present, appearing and disappearing are simultaneous, form and non-form codependent. Each term cannot exist without the other because our

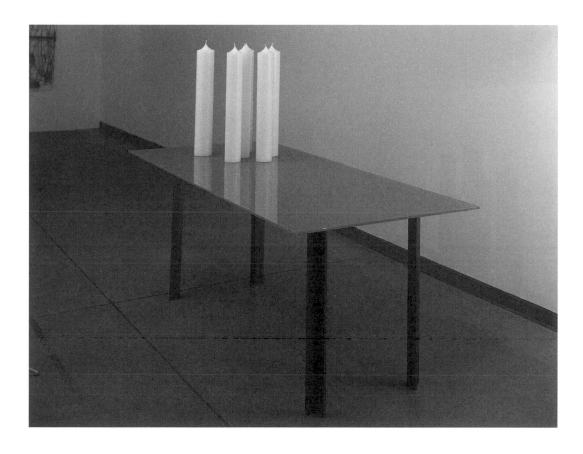

Mesa III, 2001
Steel, painted glass, candles,
59 ¼ x 80 x 36 in. (148 x 200 x 90 cm)

Following double page
Les Autres (The Others), 1992
Corten steel,
67 ¼ x 47 ¾ x 1 in. (168 x 119.5 x 2.5 cm)
74 ½ x 53 x 1 in. (186 x 132.5 x 2.5 cm)

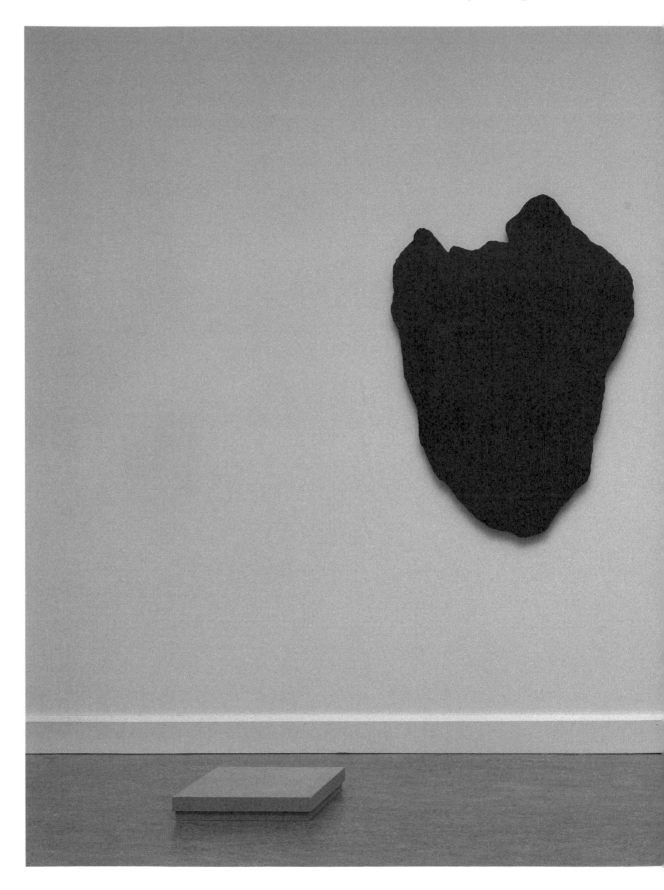

Double Miroir (Double Mirror), 1991
Steel, minium paint,
70 x 64 x 6 in. (175 x 160 x 15 cm)

consciousness of what is, could be, might be infinite or timeless, unavoidably implies the consciousness of what is not, is no more, the consciousness of our spatial and temporal finitude. When Bustamante presents "that which is not," it is to this dynamic interrelationship he appeals, rather than to a deprivation, a final absence, or a negative at the core of all beings and things.

In his work as a whole, "what is not" is also the locus for what will come to pass—the place where these fleeting, groundbreaking aesthetic experiments take place that stand as metaphors for an existence whose oscillation between the "there is" and the "there isn't" we constantly register. In this sense, nothing is fixed forever. Literally as well as figuratively, Bustamante's cutouts, his forms, should be apperceived within this interval—and not as *either* pure absence *or* pure presence, as *either* saturated images *or* voided image. In modeling this type of

Panorama Transfert, 1998
Ink on Plexiglas,
60 ½ x 98 ¾ x 1 ½ in.
(151 x 247 x 4 cm)

perception for us, Bustamante masks, covers, conceals (in *Cyprès*, *Bac à Sable*, *Sites I, II,* and *III,* and *Panoramas*, among others), but only so as to show that all these actions, acts, gestures are, when all is said and done, a question of addition and not subtraction, of form, not of formlessness.

All that remains is instilled into the visible, the tangible, into the body as much as the mind, even if many works hover at the verge, or on the *limit*—a preeminently Bustamantian term—of the imperceptible. The lessons of the Chinese treatises is of help in this respect too, since they distinguish clearly between the invisible and the unperceivable, but disregard the Western view of the bond between the invisible and intelligible, from Plotinus to Mondrian, Malevich, or Barnett Newman. There is always being, even in something, which appears impossible to apprehend, because it is "in the order of something so 'tenuous' that, if one looks at it, 'it can no longer be perceived'; or so 'subtle' that, if one listens to it, 'it can no longer be heard'; or so 'insubstantial' that, if one

touches it, 'one cannot get a grip on it' "[8]—such a phenomenon remains permanently, indefinitely awaiting approachability.

Even more than the series of *Lumières* (Lights), where forms and images surge out of the wall to which they are fixed, the *Panoramas* sequence concentrates on developing the juxtaposition of one material on another—colors on Plexiglas, Plexiglas on the wall—for the final image to appear (as when one prints a photo), but at this point the gestural operates at that fulcrum between the imperceptible and pictorial overload. Moreover, the latter sometimes blocks the shift, or the access, to the visible—or, more specifically, to the mural support intended to render the inscriptions on the Plexiglas visible. Probably, beyond the wall, we would still see colored marks, lines, holes, grids, or broad monochrome stripes, the Plexiglas preserving the potential for appearance—like an undisclosed form that awaits only the right material for it to literally reveal itself. The displacement performed by Bustamante is not, however,

Site I, 1991
Steel, minium paint, wax,
15 ¼ ft. x 14 ⅓ ft. x 16 ½ in.
(456 x 430 x 41 cm)

Lumière 14C.92 (Light 14C.92),
1992
Ink on Plexiglas,
74 x 55 ¼ x 1 ½ in. (185 x 138 x 4 cm)

Lumière 9.91 (Light 9.91), 1991
Ink on Plexiglas,
74 x 58 x 1 ½ in. (185 x 145 x 4 cm)
View of the exhibition, Centre National
de la Photographie, Paris, 1999

limited solely to a series of transfers from drawings on paper to enlargements on Plexiglas that are then finally affixed to a wall. This is because, for the imperceptible to become perceptible as such, as it totters on the edge of almost nothing, on the point of petering out, it has to be resituated within a perceptual and thoroughly concrete, material, intact reality. Only then can one understand that the unperceivable exists. This procedure is a synthetic image of the majority of Bustamante's pieces that

The Size of the Matter

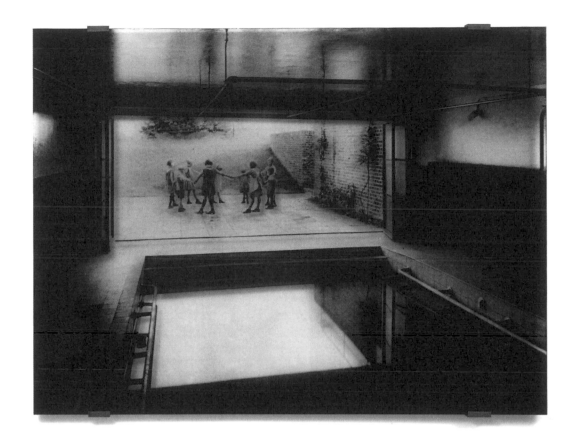

Lumière 6.91 (Light 6.91), 1991
Ink on Plexiglas,
58 x 74 x 1 ½ in. (145 x 185 x 4 cm)

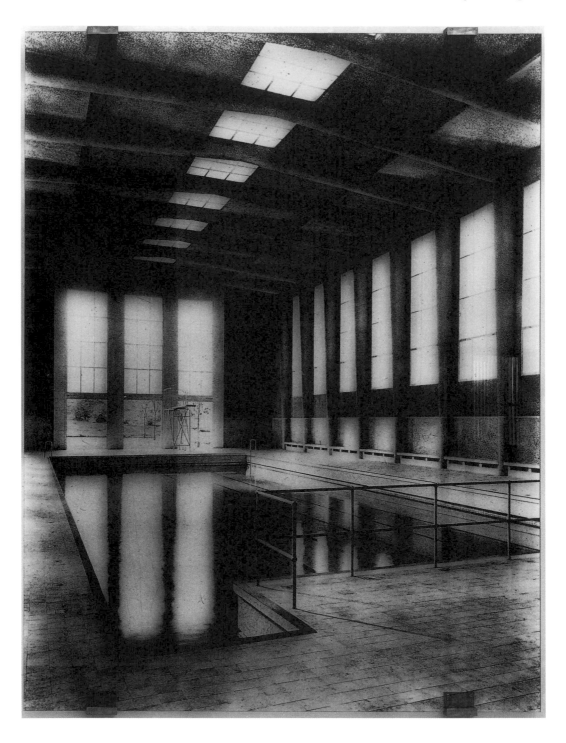

Suspension II2.98, 1998
Ink on Plexiglas,
69 ¼ x 54 ½ x 1 ½ in. (173 x 136 x 4 cm)

underline, not the inanity of the visible, of the trace, of presence or perception, but its full constitution and substance when one is confronted with its obverse—here, with its "blind wall," without image or form.

For, as Chinese painters again say, one should neither "abandon" the image, nor "stick" to it, because "the trace is precisely *between* the 'there is' and the 'there isn't'; its status is one of an actualization from which one dis-adheres—something passed through, but not 'stuck' to, 'released' (deployed), but at the same time 'recaptured,' salient, visible, and capable even of manifesting the visible, but remaining evanescent, and, thereby, unconstrained. It is present, but pervaded by absence, and, if it is a sign *of*, then it is of parting; at once full and empty, concretely formed and at the same time evasive, tangible as simultaneously it escapes."[9]

Recent works, such as *Beau fixe* (2004)—in which one visually passes through diverse layers of materials and states—combine Plexiglas, silk-screen ink, and zinc-coated metal, transparency and opacity, to affirm as much a sort of impenetrable concreteness of the material as the possibility of

**Aérogramme mentholé
(Mentholated Aerogram)**, 1997
Ink on Plexiglas,
48 x 76 x 1 ½ in. (120 x 190 x 4 cm)

crossing through them. Beyond the plastic nature of these forms and colors, beyond the interplay between materials and formats, where, once again, a multiplicity of sensations are at the same time offered up yet concealed, it is evident that it is the gearing of the perceptual that predominates.

Nevertheless, it must be inscribed into the real, into matter and materials, as a perception is capable of modifying another perception only if one state modifies another. The series of works, *Trophées* (2005), features various sense modalities that deal with the translucent and the opaque, even progressions of a glance, which drifts from metal section to Plexiglas, then on from Plexiglas to wall, from the contrast between the manual trace of the drawing and the coarsely cut metal, soliciting visual and corporeal adaptations—like a place, as much physical as mental, where we can take up a space or take on a form.

It should be stressed that, if Bustamante's work, his manner of operating with matter, self-evidently amounts to sectioning off elements independent of the viewer, he makes metaphorically visible the ways in which we form the reality in which we act and with which we interact—hence the impact of the perceived on our perception. Also, a committed act of perception is no mere agglomerate of sensations arising from the beauty of a reflection, from the granulation of a plate, the warmth of a color or the chill of metal, those celebrated optical and tactile effects inherent in sculpture; it is rather the engagement of our entire being that is convened. Bustamante invariably physically confronts the viewer with the reality she carries within her, that she bears with her as the interrelationship unfolds. Out of these various confrontations there is born a mode of perceiving objects and beings that in its turn fashions human reality. Or, rather, a certain human reality, since there's no question here of trying to define its "essence," even if a number of its characteristics will be revealed as the how and the why of the visible are drawn to the surface.

It is rarely adequately stressed that the description "without qualities" that Bustamante invokes (derived from Robert Musil's novel, *The Man Without Qualities*) possesses a precise meaning: that of a man

**Aérogramme Granit
(Granite Aerogram)**, 1997
Ink on Plexiglas,
48 x 72 x 1 ½ in. (120 x 180 x 4 cm)

who is without essence, not entirely determined or characterized. Bustamante's endeavor then cannot be boiled down to a desire to escape ultimately essentialist definitions in art; it also wants to escape from ultimate meanings on a human level. This *de*-essentializing concerns simultaneously images and objects, photographs and sculptures, which once and for all are framed in order to preclude their characterization, and, consequently, to avoid inculcating into viewers an essence liable to imprison or oppress them. Once again, this concurs with the findings of the Chinese painters:

Trophée 3 (Trophy 3), 2005
Galvanized steel, ink on Plexiglas,
42 ¾ x 51 ¼ in. (1.07 x 1.28 m)

To render their evasiveness, things have to be evoked, not however in the objectifying fullness of their presence, overwhelming the eye with distinctive features, but on the brink of invisibility, on the threshold of their emergence or reabsorption; in short, the only way of grasping this penetrating blur will be to work from behind, in the obverse of characterization, and to *de*-characterize; the only way to paint will be to *de*-paint.[10]

In the majority of his pieces, Bustamante has followed the same course. What has been reckoned in his work as an emptying, an absence or withdrawal, is in fact the enduring will to *de*-paint, *de*-sculpt, *de*-photograph.

Above and beyond these astonishing overlaps with a Chinese pictorial tradition two thousand years old, the question remains as to what Bustamante's *project* consists in, since it is clearly not a simple restatement of the ineffable essence of painting and sculpture, nor of the predicament of being and not being form, of being and not being image

Draft for **Origines**, 1992

or object—though, being prepared to jettison one's Western self-importance for a moment, it is as well to keep in mind the extreme complexity of this reflection, which promptly reappears in a great part of the Bustamantian project: how can one live (in) space *and* be detached from space? Once photographed, landscapes, urban outskirts, cities, men and women should constitute images of this space—while sculptures and installations should constitute their objects. But such a typology misses the mark, if only because our body exists just as much (if differently, certainly) in a space made up solely of photographs as in one composed of

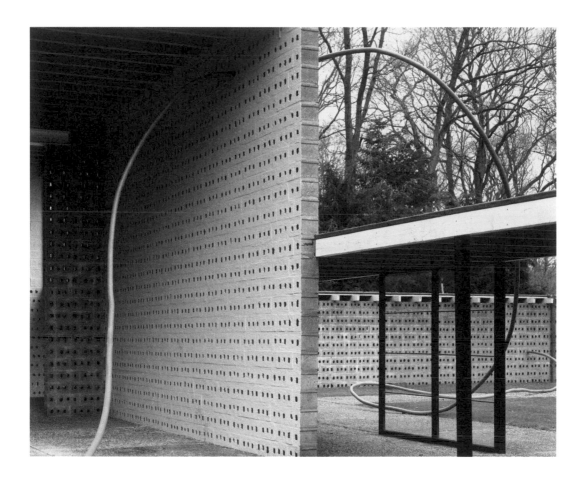

Serena, 1994
Vulcanized rubber on metal
Length: 400 ft. (120 m)
Diameter: 2 ¾ in. (7 cm)
Permanent work,
Kröller-Müller Museum, Otterlo

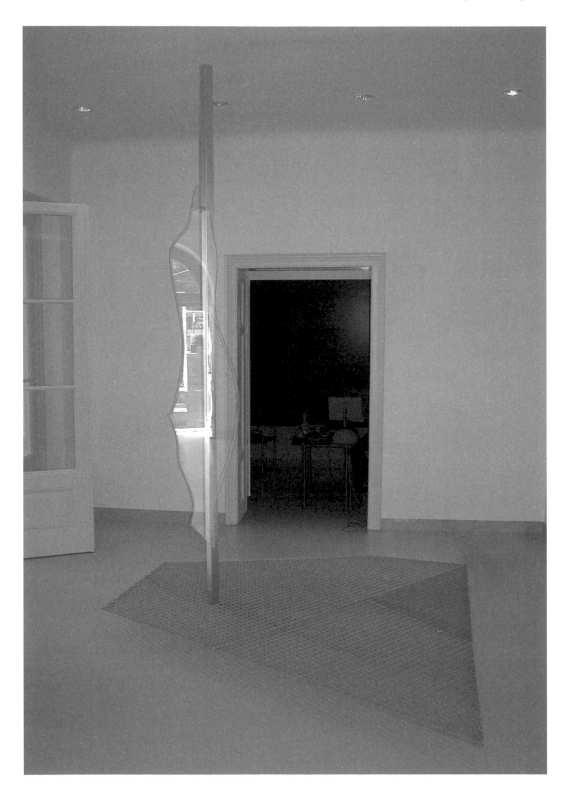

Manège II (Merry-go-Round II), 2003
Zinc-plated steel, metal, glass,
11 ²/₃ x 10 ¹/₃ x 8 ²/₃ ft. (3.5 x 3.1 x 2.6 m)

real volume and mass. Rather than as a simple presence confronted by different plastic forms, a body is shown more revealingly when captured in some human action—be it action in the sense of the work performed on nature or the cityscapes presented in the photographs, or the one the artist effects on his materials, or again in the engagement of our body confronted with an artwork.

Whereas Bustamante's enterprise takes a step back as it were from language (even when more than one individual appears, people are very seldom represented talking to each other in the photographs), it is still patently human acts in every kind of territory, as well as human action within society, that forges the bonds without which there can be no inter-human world. One might find this obvious, since it is precisely neither more nor less than what one sees, or senses, in the *Tableaux*, *Intérieurs*, *Sites*, *Mesas*, and in *Something Is Missing*, and even more in the installations that hybridize the genres. In this respect, the importance Bustamante attaches to architecture—the installation in the Haus Lange, the interventions on Rietveld's Pavilion (*Serena*, 1994), on the Von Humboldt Library in Berlin (1995), the *Maison Close* and *Les Amazones* at the Pavilion at the Venice Biennale—is the most evident link with human activities in general and with the history of humankind. But human activity or history "in general"

Panorama Barbed Threads,
2000
Ink on Plexiglas,
58 x 114 x 2 ½ in. (145 x 285 x 6 cm)

conceals a far from self-evident type of action. If one takes into account the obliteration of the human figure, in conjunction with its concomitant exaltation, this "self-obliteration" of human action is perplexing indeed.

To cover over, so as to conceal and hide, but also in order to open up onto other forms and subjects; this is Bustamante's generic gesture—in photography, in sculpture, in drawing. It might be tempting to see it as a bearer of reality in the photographs, while it allows free rein to the imagination in the majority of the sculptural works; this, though, would once again cleave into two a project entirely preoccupied with how

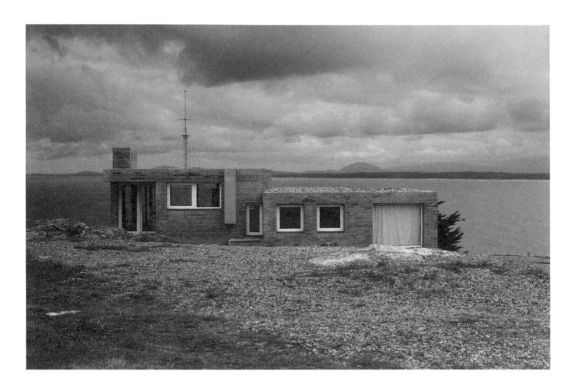

S.I.M.19.97, 1997
Color photograph, 16 x 24 in.
(40 x 60 cm)

The Size of the Matter

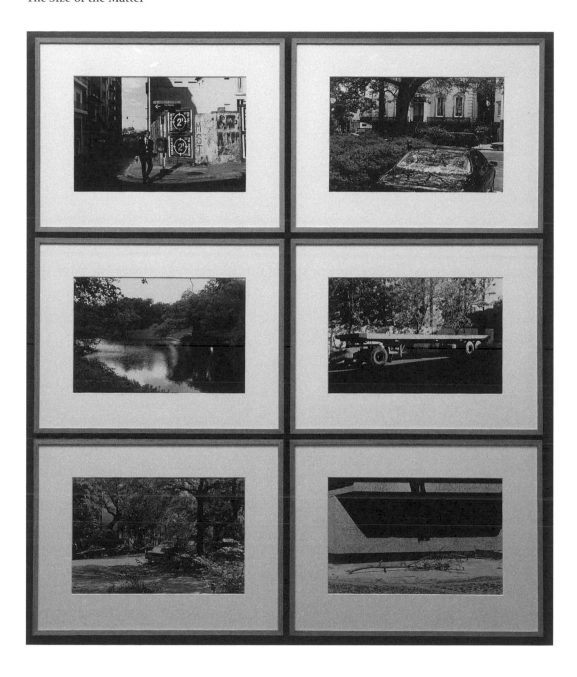

S.I.M.8.97, 1997
Six color photographs;
each photograph 16 x 24 in.
(40 x 60 cm)

humankind inscribes itself within the world. Action, work, technology, production, creation—everything that pertains to the modification or organization of matter, that which one sees in the photographs going hand in hand with the invention of plastic forms in other areas—all this partakes of a process of sociality, of inscription within an inter-human reality. All this is only rarely tackled in analyses of his work, often treated as dealing only in objects and lines, with mass and color; and such a reading can easily descend into formalism, whereas Bustamante's idea is to hunt down forms that run counter to plastic formalization and to the formalization of thought. It is true that Bustamante's creative processes are more decipherable when approached diachronically and not synchronically, so distant, so dislocated are the quantitative and qualitative shifts between works—with the links between them surfacing sometimes only long after the impact of a given work has subsided.

One particularly striking work is a group photograph in *Something Is Missing 4* (1997),[11] showing an inscription embroidered on a scarf belonging

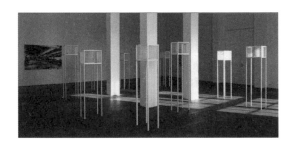

Suspension I, 1996
Eleven metal cages with
live finches
(diamond mandarins)
78, 74, 72, 70, 68 x 12 x 18 ½ in.
(195, 185, 180, 175, 170 x 30 x
46 cm)

to one of the mothers on the Plaza de Mayo in Buenos Aires that reads quite distinctly, *desaparecidos* ("disappeared"). It would be going too far to treat this image as a kind of symbolic emblem or condensed vision of Bustamante's entire career, from a sociopolitical perspective this time, however allusively referenced, even if it at once reminds one of other works, as if by a process of retroactive exposition, works such as *Sites*, *Bac à sable*, *Lumières*, the *Panoramas*, all of which deal, in varying degrees and in diverse forms, with disappearance or with the disappeared, with overlying or with obliteration.

Admittedly terse, such a reading is not—for all that—reductive, because Jean-Marc Bustamante's work is anchored in human reality and human action (that of the mothers on the Plaza de Mayo being exemplary in this respect). Though trailing in its wake countless connotations and endless aesthetic and artistic traditions, it is the term "realism" that

survives as the most appropriate one for Bustamante's oeuvre. It is a realism that is not immediately posited, not clearly visible. A realism that stands to one side, on the margins, on the fringes, though it tirelessly distills a presence. To envisage recent pieces (the *Panoramas*, the *Amazones* at the Venice Pavilion, for instance) solely as masterful exercises in style, as consummate games with material and form, is to discount a human reality whose presence and action is visible everywhere. In place of a frontal realism or reality, Bustamante prefers an allusive, suggestive, abbreviated realism whose power of immanence is such that to labor its characteristics leads only to superficiality, to intellectual vacuousness.

Still, due to the mere presence of the materials, their pregnant colors and forms, the sheer might of the built environment, suggestion or allusion are not what immediately comes to mind on looking at

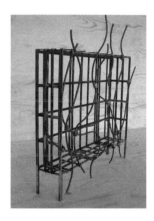

Project for a public sculpture,
2005
Steel, paint, 26 ²/₃ x 20 x 5 ft.
(8 x 6 x 1.5 m)

interventions such as that at Mies van der Rohe's Haus Lange, the Rietveld Pavilion, the Von Humboldt Library in Berlin, the Venice Pavilion, or again in the construction of the *Maison Close*. Sometimes, as in the imposing *Lava I* (2003), the sculptural tends so markedly to the architectural that the roles seem to all intents and purposes to have been reversed and the surrounding space appears *installed* in the sculpture. The effect in *Serena* is somewhat similar, the structures appearing to have been expressly conceived to sustain and drive the sinuous line. All these works present a dual face: they make clear the relations between space and visitor; they point up the fact that one is present in flesh and blood and not in some conceptual "statement"; they make the here and now a palpable experience. Yet, simultaneously, they mark out a distance, render intangible, escape from view and from the body. The gold-colored

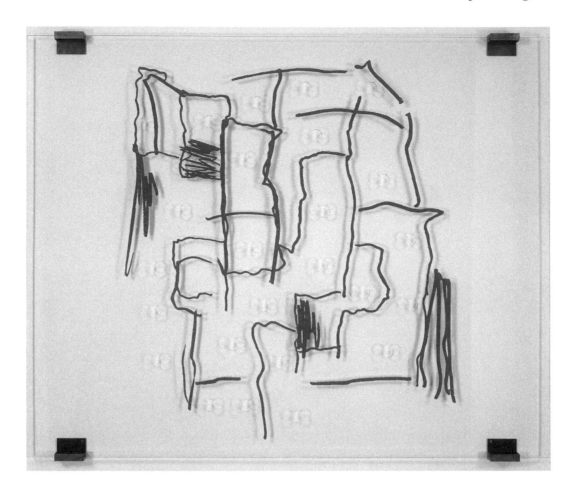

Aérogramme Aphone
(Aphonic Aerogram), 1997
Ink on Plexiglas, 58 x 74 x 1 ½ in.
(145 x 180 x 4 cm)

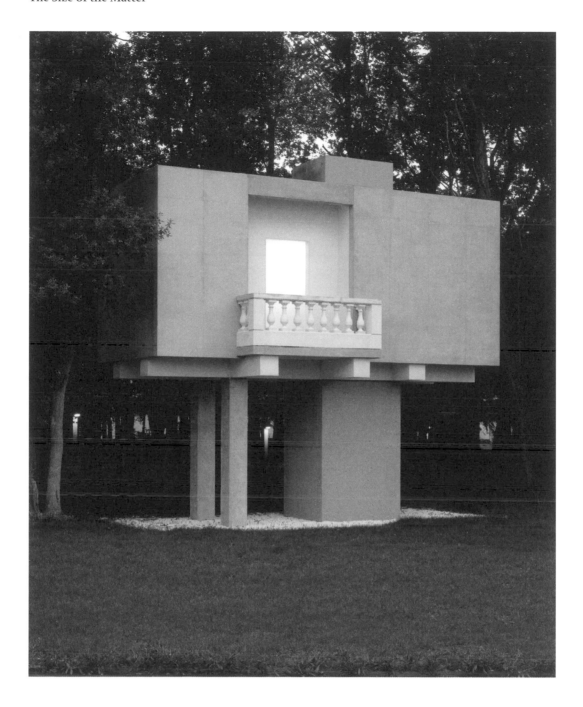

La Maison Close
(The Brothel), Orleans, 2000
Concrete, frosted glass,
randomly programmed interior
lighting, 21 ¾ x 26 ⅔ x 10 ½ ft.
(6.55 x 8 x 3.15 m)

wall in the Venice Pavilion is of that nature: as excessive visually as it was blinding. Or, rather, all the more blinding since only the thing visible is matter: no figure, no form, no space, no place can be perceived.

A stretch of gold is laid in, one without beginning or end. The *Maison Close*, a relatively welcoming structure, intermittently lit at night as if lived in, is a further metaphor for a concrete, present, conducive place, which obstinately refuses to be opened up, to be visited. This is, however, a space from which one can learn from, even though it cannot be experienced directly. The life of a space, the lived experience one can have in relation to an artwork, however closed and difficult it may be, is a way of living its space and our space, and there to take shape, to forge meanings.

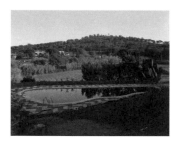

T.50.82, 1982
Color photograph,
41 ¼ x 52 in. (1.03 x 1.3 m)

Bustamante's works come issued, so to speak, with a rider, a tacit agreement with the viewer: one has to be able to throw off the habit of living in and through artworks, to unlearn one's diligent empathy with them; in other words, no longer to use or utilize them. To instrumentalize them would mean destroying their raison d'être. Through such potent space-time experiences of place—suggesting as much as they veil, presenting as much as they conceal, conditioning the body as much as they are subjected to it— one can better understand what living in and detaching oneself from space actually means to Bustamante's way of thinking.

It has nothing to do with those precepts advocating adherence to the spiritual over the material life, since here, on the contrary, the physicality of the works demands embodiment; the materials deeply stimulate our perceptions, our bodies, our experience. Bustamante's contention is quite at odds with all that: existing in space, progressing through a landscape, experiencing human relationships does not consist in oppressing objects or beings. To inhabit the world, one has to know how to detach oneself sufficiently from it so as to able to apprehend the distance that subsists between the "there is" and the "there isn't." To live

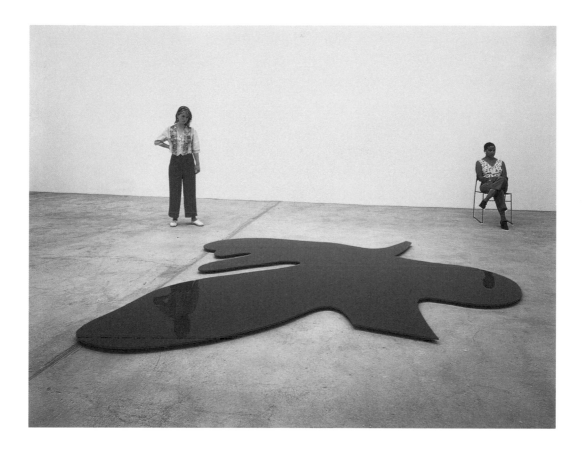

Leda, 1992
Lacquered glass, 12 x 9 ft. (3.6 x 2.7 m)

consists in settling into this fault, a fault that is also a plenitude. One of the plastic strengths of Bustamante's project resides in this extraordinary capacity for knowing how to insert something where nothing seems to exists and to withdraw something from where the visible appears to be saturated.

To painstakingly coat a plaque with layer after layer of matter (*Sites I, II* and *III*), to slice into metal in a rough and ready manner (*Lava I, Untitled*), to make holes in plates of Plexiglas (*Panorama Surroundings*), to separate planes of color (*Panorama a View—Grey*): these are time-honored gestures of the artist. Michelangelo summed them up in a famous formula encapsulating two ways of approaching sculpture and painting: by removing or by adding matter (*per forza di levare* as against *per via di porre*).

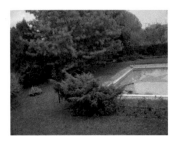

T.1.78, 1978
Color photograph,
41 ¼ x 52 in. (1.03 x 1.3 m)

In the new perception advocated by Bustamante, whatever "is not" is actually already present, already in the visible, no thing being in truth removed or excluded. Materially and formally speaking, if creation, if the production of forms, if cutting, if paintings actually exist, the process must consist in setting oneself up in reality—concrete, perceptive, imaginary reality—the better to bring out what is not, or, more exactly, what is not yet the reality that the work makes visible. This may sound like a paradox, or a truism, since what is not yet formed cannot be perceived. But this is to fall in with the Western tradition of the privation or negation of forms: in the beginning, there was just raw material; only then came the move to plastic form. Bustamante proceeds differently, in so far as he inserts the "it isn't" in the "there is"—a quite distinct process once it is understood that the first term is not an absolute nothing, the zero of forms, a nothingness from where appearance is to emerge.

Ultimately, this is a rather simple experience, one we might all have. In human reality, there is always the awareness of our finitude; in what we are there always exists what is not. One day, inevitably, we will be no more.

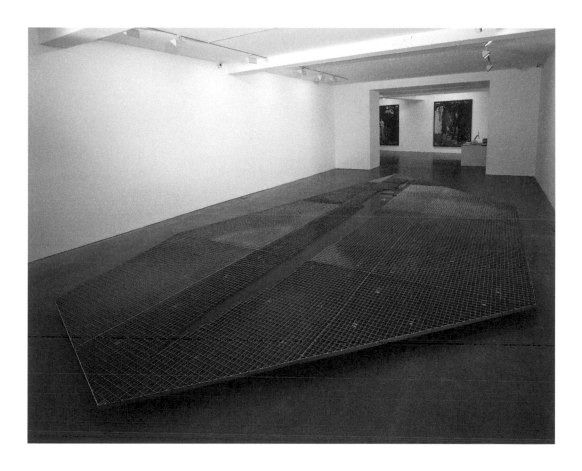

Lava I, 2003
Galvanized steel, ink on Plexiglas,
29 ¾ ft. x 14 ½ ft. x 7 ¼ in.
(892 x 438 x 18 cm)

Panorama Moby Dick, 2004
Ink on Plexiglas,
4 ¾ x 8 ½ ft. (1.45 x 2.54 m)

To be situated at the heart of the real with the more or less persistent and diffuse sense of being excluded from it, or to find oneself crushed by it—this is the origin of an unbearable angst. By rejecting scissions and dichotomies, Bustamante's work proposes circumscribed spaces and objects, in which reality is, so to speak, within reach, near our lives, and no longer an obstacle. Here once again, one has to rethink the issue of our consciousness of finitude, lest we succumb to a pure and simple negation of beings and things, to a kind of entropy that would lead us to the obliteration of forms and perception. Though there have been a few attempts in the West to think of human reality outside the dialectic between being and non-being, Jean-Marc Bustamante's oeuvre can be viewed as one of the more convincing artistic attempts.

Bustamante's position shares common ground with a phenomenological current that sought the wholesale reconsideration of what "to exist" means. In particular, to Emmanuel Lévinas's position as expressed in a brief essay, *De l'existence à l'existant*,[12] where, taking up the terms Maurice Blanchot used in his novel *Thomas l'Obscur*, he addresses the question of (what) "there is." Once again we are not as far as it might appear from Chinese thought, since Lévinas also tries to outflank the subject/object dialectic and to de-essentialize the flux of existence. And,

Panorama Valentine, 1998
Triptych, ink on Plexiglas,
6 ft. x 9 ½ ft. x 1 ½ in.
(183 x 289 x 4 cm)

oddly enough, we can hear echoes of the reading of Bustamante's work we have been following to this point. "Expressions like the 'broken world' or the 'world in upheaval,' though they have become common currency, nevertheless do express an authentic feeling. . . . For the entity [*l'être*—being] to which the disappearance of the world makes us vigilant is not a person, nor a thing, nor the totality of people and things. It's the fact that one is, the fact that *there is*. Who is or what is does not enter into communication with its existence by virtue of a decision taken prior to the play starting, before the curtain rises. It assumes this existence

precisely by already existing."[13] This impersonal "there is" is what is in general; it does not qualify or characterize anything other than the fact that there is something, something that is concurrently concealed. And Bustamante's works also indicate, demonstrate, record this simple state of things: things which are and things which are not.

In the same way, for Lévinas "this nothing is that of a pure nothingness. There is no more this or that; it's not 'something.' Yet this universal absence is, in turn, a presence, an absolutely inevitable presence. . . . It's immediately there. *There is* in general, without what there is being important, without one being able to affix a substantive to the phrase, *There is*—an impersonal form, like, it's raining, or it's hot. An essential anonymity."[14]

As for those works by Bustamante that show what is not, that allow us to live (in) space and excise us from it, the statement that things are there, that they are present while being absent, leads us to rethink our presence-absence to things and beings, not on a negative but on a dynamic mode, and should urge us to break free of this "inhuman *neutrality*" imposed on us by the *there is*. As Lévinas declares with emphasis: "The caress of the *there is*—that is pure horror. . . . To possess consciousness is to be ripped from the *there is*, since the existence of a consciousness constitutes a subjectivity."[15]

Undoubtedly, Bustamante's works do not illustrate a theory or concept. They remain, however, coupled with a reflection concerning humankind and its products, concerning what it is to exist and how to exist during an aesthetic experience. To perceive a piece solely as an interesting, beautiful, or even unappealing "work of art" is to succumb to this neutrality from which his work does its utmost to escape. Even when, as in the *Panoramas*, the Plexiglas is so translucent, or has become transparent, that we seem to fall short or overshoot something that in the last analysis remains beyond our grasp—since it is imperceptible, unseen. As with the *Verre bleu*, *Leda*, or *Lava I*—virtually flowing patches of color—the *Panoramas* reflect our moving, living image, clearly present and integrated into them thanks to the introduction of the use of mirrors.

However slender, however infinitesimal, so much so that we seem almost not to be able to see it anymore, everywhere the inscription of man reemerges—his trace, his way of being.

In memory of Marion Sauvaire

1. Cf. *Bustamante*, book published for the French Pavilion at the fiftieth Venice Biennial (Paris: Gallimard, 2003), a text that continuously draws intriguing parallels with other artists.
2. The complete series is reproduced in J.-M. Bustamante, *Oeuvres photographiques 1978–1999* (Paris: Centre National de la Photographie, 1999).
3. Michel Leiris, "Fibrilles" (1966), in *La règle du jeu* (Paris: Gallimard, 2003), 540.
4. See J.-M. Bustamante, *Lent retour* (Paris: Galerie Nationale du Jeu de Paume, 1996); for example: "I present neither emptiness, nor neutrality, nor banality. I affirm the fullness of presence," 33.
5. François Jullien, *La grande image n'a pas de forme, ou du non-objet par la peinture* (Paris: Seuil, 2003).
6. F. Jullien, *La grande image*, 20 and 22.
7. Ibid., 35; Tang Ziqhi, quoted by F. Jullien.
8. Ibid., 59.
9. Ibid., 156.
10. Ibid., 61.
11. Catalog *J.-M. Bustamante*, CNP, 146–147.
12. Emmanuel Lévinas, *De l'existence à l'existant* (Paris: Vrin, 1990).
13. Ibid., 25–26.
14. Ibid., 94–95.
15. Ibid., 98.

Out of Focus
Ulrich Loock

T.2A.78, 1978
Color photograph,
41 ¼ x 52 in. (1.03 x 1.3 m)

Jean-Marc Bustamante belongs to a generation of artists who returned to the object in the 1980s—after a period marked by a turn toward the linguistic and written condition of the artwork. A return: the projects of minimal art were still unfinished business. The factual nature of the minimalist object, the formal and material economy of minimalist sculptural practice, the shift of interest toward the place of the work in the art of Andre, Judd, or Flavin, appeared as a model of art that was not finally "overcome" by conceptualism, and which could serve as a precondition for new and particular conceptions of the object. One crucial condition for this return, however, was the critique of the exclusive character of modernism, both set in motion and resisted by minimalism, which would receive its explicit (artistic) formulations from the late 1960s onward particularly in France (BMPT, Cadere). Bustamente's connection with the object-conceptions of minimal art—and much the same may be said of a number of artists of his generation, such as Vercruysse, Mucha,

Regrets, 1991
Steel, minium paint, wax,
12 x 49 ½ x 63 ¾ in. (30 x 126 x 162 cm)

Schütte, Klingelhöller, Iglesias, and also Gober, etc.—can thus be nothing but critical.

In his early work (from 1978), however, Bustamente made not objects but photographs (*Tableaux*), and later, after his collaboration with Bernard Bazile (1982–87), he marked the start of his independent works with three pictures, for each of which he enlarged an illustration from a book about exhibition design and then silk screen-printed them on Plexiglas (*Lumières*). After this he made—and this work has not yet been completed—further series of photographs (*Something Is Missing, L.P., Amazones*), and other two-dimensional works with which he extended the range of the photographic image (*Panoramas*). Photographic works, or works related to photographs, run through the whole of his oeuvre. Bustamente's origins in photography placed him in a particular position (not least in relation to other artists of his own generation, who likewise

formulated their work as object-based practice): from the time of its invention, photography was anathema to modernism, before it became the crucial medium of the avant-garde escape from the "institution of art" (Peter Bürger). By virtue of their photographic nature, Bustamante's works were essentially, constitutionally, and unquestionably associated with objects outside the image, with the things of extra-pictorial reality.

When Bustamante finally made his first objects (from 1988), they were marked by the referential character that photography brings with it by its very essence, and the rejection of which is part of the fundamental definition of modern (and minimal) art. Some of these three-dimensional works are based on objects depicted in the artist's own photographs, or in photographs by others. Others reconstruct—in various kinds of transformation—objects from design history. Finally, in an essay in the volume published to coincide with Bustamante's participation in the 2003 Venice Biennale, Jean-Pierre Criqui showed that Bustamante's forms and figures fundamentally derive from already existing models, highly diverse examples from art history. Using the concept of "intertextuality," Criqui was able to show that Bustamante conceived of the artist, himself, not as a superior, self-sufficient author, but as a producer whose basic material includes not only physical matter, but also already developed cultural objects. This kind of critique of the status of the "author" is something that Bustamante shared with many artists of the time, the works of Barthes and Foucault having provided the founding formulations of this discourse. Photographic practice itself, because of its mechanization, is an outstanding means of de-subjectifying the production of images: at around the time when Bustamante began to make his works, it was being used in this sense by artists such as Cindy Sherman, Sherrie Levine, and Richard Prince (although equally it should not be forgotten that Bustamante, already influenced by his training, began more as a "real" photographer). But the most interesting result of Criqui's investigation is the understanding that Bustamante's references (in art history) are extremely diverse and chosen—seemingly—at random. It is precisely this distraction, however, that creates a curious cohesion between the individual works and groups of works, without ever calling their diversity into question.

In some of his exhibitions Bustamante connects photographs, which he has taken himself and printed on paper, with objects, images printed on

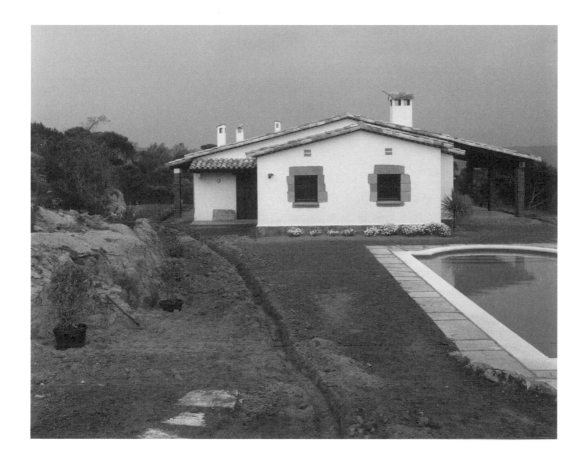

T.42.81, 1981
Color photograph,
41 ¼ x 40 in. (1.03 x 1 m)

Plexiglas (*Lumières*), his own drawings, enlarged and also silk screen-printed on Plexiglas (*Panoramas*) and other works which extend these categories and shift the boundaries between them. Thus photography appears as a more or less clearly distinct branch within a polymorphous body of work. But the photographs from 1978 to 1982 reveal paradigmatic decisions. In retrospect it becomes apparent that they not only form a single block of work that stands at the start of Bustamante's artistic activity (and which he later extends), but that the structures and orientations of Bustamante's oeuvre as a whole are preformed and predetermined by the specific conception of the photographic image.

The same is not true of all the photographs. But in many of them an individual element or an object is placed at the center of the picture in

T.63.82, 1982
Color photograph,
41 ¼ x 52 in. (1.03 x 1.3 m)

such a way that the center appears to be concealed or emptied. The center of a picture is a prominent place, the point on which the eye concentrates so automatically that this focus appears entirely natural. On the other hand, one of the accomplishments of modernist pictorial work has been to question the preeminence of the center of the picture, and create compositions that extend equally over the entire picture surface. At the focal point of many of Bustamante's early photographs, conspicuously emphasized within the context of the situation, is one element of a damaged and disorganized region that is neither a natural nor an urban landscape, but rather an intermediate, indefinable zone, such as a sparse-looking bush (*T.3.78*), an empty swimming pool (*T.15.78*), a pine tree (*T.21.78*), a holiday home (*T.45.81*), a tree partially concealing a holiday home (*T.63.82*), etc. This kind of focus acts as a challenge to the modernist conception of de-centered pictorial organization; it displays a directness and a ruthlessness toward the demands of the elaborated composition that evokes Frank Stella's statement from the mid-1960s, that the response of the new American painting—in the debate with "relational painting"

and with the current European perspective—was to place the object directly at the center.

In Bustamante's photographs this kind of placing implies an iconographic significance: it reflects the way in which an expanding urban civilization makes use of the landscape. But it brings about something else as well: the object that occupies the center of the picture as part of an essentially disparate situation, can, for example, be a tree removed from the overall context of things, making it impossible for the eye to enter the depth of the picture, or an unfinished architectural structure, a closed-up holiday home or an empty swimming pool that reveals "nothing." The gaze is not led towards the central positioning of such objects by the organization of the other elements in the picture, and neither are they themselves sufficiently interesting to justify being privileged in this way. Thus the center of the picture is stripped of the functional significance that it usually possesses for the organization of the picture as a whole, and the focus of the picture is either hidden or emptied. The gaze is not led to this center, or held by it. Immediately attracted by the central objects, it slides away from them, and becomes unpredictably lost among all the other objects recorded on the surface of the image. Freed from the power of an organizational center, and outside compositional connections, these objects appear in a form that allows their objective and material autonomy to emerge in a most strange and unusual way. Very particularly, this disconnection encourages them to be seen in a way that is not defined by any overarching significance, such as the meaning of "a landscape ruined by real estate speculation," but which instead sees each individual object as though it were without meaning, as though it were simply there for its own sake, entirely independent of any position taken by the viewer.

The title that Bustamante gives to these photographs, *Tableaux* (he originally called them *Sites*), makes one think of "painting" in a very particular sense, in the sense that the painting is seen as resembling a top, like the top of a table. The most diverse objects can be laid on a table without any one of them disturbing the other, each for a different reason, each bound up with a different activity, always ready to be moved this way and that, cleared away and placed somewhere else. This vision of the painting as a table top is reminiscent of Isidore Ducasse, Count of Lautéamont's celebrated analogy for beauty: "As beautiful as the chance encounter of an umbrella and a sewing machine on a dissecting table."

T.03.78, 1978
Color photograph,
41 ¼ x 52 in. (1.03 x 1.3 m)

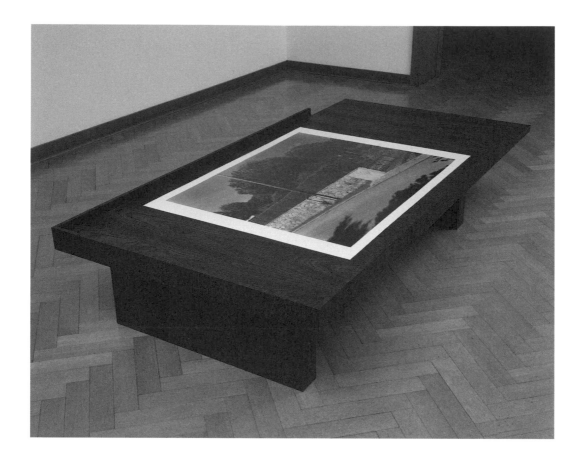

Ouverture I, 1993
Wood, color photograph,
17 ¼ x 84 x 48 in.
(43 x 210 x 120 cm)

Such arbitrary arrangements of things are realized by Bustamante's photographs, although unlike the Surrealists he doesn't expect them to make poetic sparks. Their presence together in the *Tableaux* allows objects to exist inertly, as themselves.

The concealment or emptying of the focal point of the picture by the use of a central motif, or by the introduction of empty spaces (*T.17.79*), barriers consisting of rows of trees (*T.17.78*, *T.25.78*), or slopes of broken earth (*T.14.78*, *T.32.80*), are different ways of creating a situation within the representational system of photography, in which the pictorial space loses its power to submit objects to an apparently natural order that was first developed by the painter-scientists of the Renaissance. There is nothing to suggest that a *Tableau* should not be seen as "straight photography," but the way in which Bustamante aims the lens of his camera at the landscape enables him to transform the (imaginary) piercing of the picture surface—"perspective"— into a (real) diversion of the eye across the pictorial field. The desolate, even disorganized landscape that Bustamante depicts, fully matches his intentions. What is later represented in the series of *Cyprès*, 1991, a dense curtain of cypresses above a thin strip of wall, already outlined in an older *Tableau* (*T.25.78*) of which the *Cyprès* are details, is nothing but the identification of the motif with the surface, the explicit closure of the pictorial space. The original relationship of photography to reality is employed in such a way that the objects can be

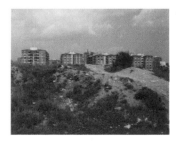

T.32.80, 1980
Color photograph,
41 ¼ x 52 in. (1.03 x 1.3 m)

and must be viewed in quiet contemplation without considering their significance. The viewer is excluded from them to the extent that Bustamante's pictorial strategy is to show objects in their singularity, as material realities; but, since perspective is deflected, the viewer is held back from (imaginary) physical contact with them. This exclusion of the viewer, which runs firmly against the conventions of photography of a perspectival orientation, is a precondition that allows things to appear in

all their untouched peculiarity. One indicator of the special place of the physical viewer is the almost complete absence of human figures, the lack of anyone facing the viewer in these pictures of landscapes, all of which are marked by traces of human intervention.

Photographic works that Bustamante integrated into the *Pavillon des Amazones* in 2003, his contribution to the French pavilion at the Venice Biennale, appear to contradict the earlier photographs of unpopulated landscapes. After about twenty-five years of artistic practice, Bustamante is

Intérieur II, 1987
Varnished solid oak,
86 ¾ x 34 x 76 in.
(217 x 85 x 190 cm)

doing something that he had previously refused to do. At the same time, it is noteworthy that, unlike an artist such as Thomas Struth—who began making portrait photographs at a particular moment in time, after previously insisting rigorously on a lack of human figures in the streets that he shot from a central perspective—Bustamante has not developed a form for his own portrait photographs that is fundamentally different from the form he employed for his landscape pictures. He positions the young women in the middle of the picture, or slightly off-center; he returns to landscapes resembling those in his earlier photographs; and above all he ensures that the young women's clothing and chosen posture make them appear alien to the place in which they are depicted. Again, they stand or crouch on slopes, as though their stay in this place were uncertain and transitory. Additionally, their identification as "Amazons," female warriors from Greek mythology, refers to their inappropriateness in the location. Bustamante now depicts human figures, but at the same time he makes it clear that they don't belong in the place where they are shown.

On the other hand, the young people who are shown in groups, some of them averted from the viewer, in chance arrangements—they are

Portraits T.C.B1.02, 2002
Color photograph,
90 ¾ x 72 in. (2.27 x 1.8 m)

images of party goers taken from the Internet—are integrated within their surroundings. But their environments are formed of nothing but light and darkness—consequently these works are realized as *Lumières*, as silk-screen prints on Plexiglas held a few inches away from the wall. The figures look like ghostly apparitions in dematerialized surroundings. These, then, are the alternatives that Bustamante opens up in his more recent works for the previously withheld presence of human figures in his pictures: either they are alien to the place in which they are present, or their appearance is unreal from the outset. This return of the body is not really a revision of its former exclusion. On the contrary: its compromised presence in the photographic surroundings reflects the modality of the presence of visitors at the French Pavilion who, as is shown by corresponding photographs in a 2003 catalog by the Timothy Taylor Gallery, are kept away from the middle of the main space by a large floor

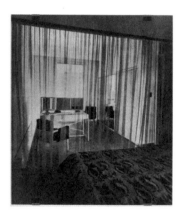

**Lumière 3.87
(Light 3.87)**, 1987
Ink on Plexiglas,
70 x 58 x 1 ½ in.
(175 x 145 x 4 cm)

sculpture, and respond with curious helplessness to the photographs of the "Amazons" (unlike the public in Struth's museum photographs).

 The first works that Bustamante made on his own in 1987, after the end of his five-year collaboration with Bernard Bazile, include three pictures that are called *Lumières* (later, but only after two years, further *Lumières* were made). We might say that with these works Bustamante is reflecting upon his own earlier photography, that with these pictures, themselves photographs, he is presenting a "theory" (in the original sense of that word, meaning "view") of his photography—there must be a connection between the "theorization" of photography and the decision to realize things drawn from photographs in the form of three-dimensional objects. Two of the *Lumières* show lamps; the third shows an illuminated

room separated off from a further, dark room by a transparent curtain. The *Lumières* are taken from various publications, the first three from a 1960s book about exhibition design. The black-and-white book illustrations are enlarged and silk screen-printed on sheets of Plexiglas that are held at a certain distance from the wall by massive brackets.

The *Lumières*, from 1987 onwards, evoke the constituent elements of photography point by point: with the real transparency of the Plexiglas sheet and the transparency, iconographically, of the curtain, they evoke the window-like quality of the photographic image, which, by virtue of its mechanically generated perspective, guarantees an imaginary view through the real surface and into the depth of the space. With the explicit visibility of the black raster dots of the extremely enlarged depiction, they evoke the alternatives of black and white, positive and negative, brightness and darkness, presence and absence. With the reflection of the light by

Lumière 5A.89 (Light 5A.89),
1989
Ink on Plexiglas,
58 x 74 x 1 ½ in.
(145 x 185 x 4 cm)

the white wall, visible through the Plexiglas sheet, and—iconographically—the depicted lamps, they evoke the essence of photography as a record of incoming light. But this self-reflexivity of the medium of photography is, at the same time, shattered point by point in a process of deconstruction: the real, and not only imaginary transparency of the picture leads the eye no farther than the impenetrable wall of the space in which the picture is fixed with its conspicuous metal brackets. The raster dots confirm that the picture consists of printed color on Plexiglas, not light recorded through the grain. The light of the picture is not the recorded light of the photograph, but the real light of the exhibition space. With his object, *Paysage I*, 1988, Bustamante returns to the theme of the window as a metaphor for photography—his landscape photographs—in order to decline within a three-dimensional and not "pictorial" form, the deconstruction of transparency and the simultaneous granting and refusal of "perspective."

The *Lumières*—the very term plays a part in the deconstruction of "photography" ("lights" as a distorted reproduction of the "recording of light") are photographic images which reveal, in the form of a (non-)transparent object from the real world (the printed Plexiglas sheet) what the illustration shows. But the explicit deconstruction of photography might be the very thing that allows Bustamante, from 1989 onward, to show perspectival, and sometimes populated spaces in the manner of the *Lumières*, the reproduction of which must remain excluded from the *Tableaux*.

In a number of respects, Bustamante's photographs have a paradigmatic function within the whole of his work: with regards to their

T.21.78, 1978
Color photograph,
41 ¼ x 40 in. (1.03 x 1.3 m)

abundance of reality (in the dual sense of the plenitude of elements of reality as well as the absence of an imaginary "perspective"), the realization of a state in which objects are both free of meaning and very much themselves, and as regards the exclusion of the body, even if it is allowed back in more recent photographic works—albeit under very specific conditions.

The exclusion of the body is the price to be paid for the return of the reality of the object, and thus also for the rejection of a modernity defined by its exclusive nature. Bustamante's objects from 1988 are imbued with the conditions laid down by his photographic work. To put it another way, Bustamante opposes the abstractions of minimal art, the reduction of the object to its materiality, its size, and its location, the interaction with viewers, even if they are generic viewers—Andre's carpet of steel plates as a stage for a performance, Flavin's Light Rooms as atmosphere—while he makes the object concrete and objective, sometimes in a direct, polemic, and ironic reference to Judd's boxes, but removed from any physical contact. These conditions reflect the understanding that the situation of an artist in the 1980s is not that of an

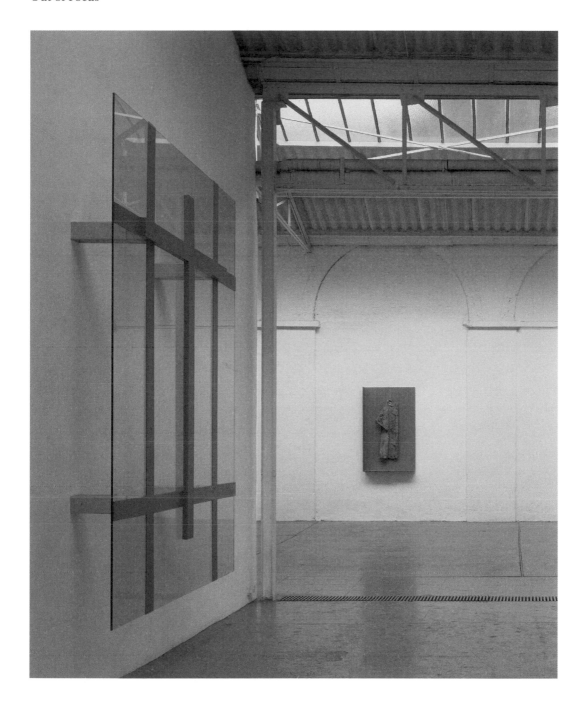

Paysage I (Landscape I), 1988
Glass, steel,
9 x 6 ²/₃ x 1 ½ ft. (270 x 200 x 44 cm)
Le Vêtement (The Garment), 1988
Steel, seventeenth-century court
dress, minium paint

Following double page
Lumière 02.03 (Light 02.03), 2003
Ink on Plexiglas,
78 x 111 x 1 ½ in./56 x 68 x 1 ½ in.
(195 x 280 x 4 cm/140 x 170 x 4 cm)

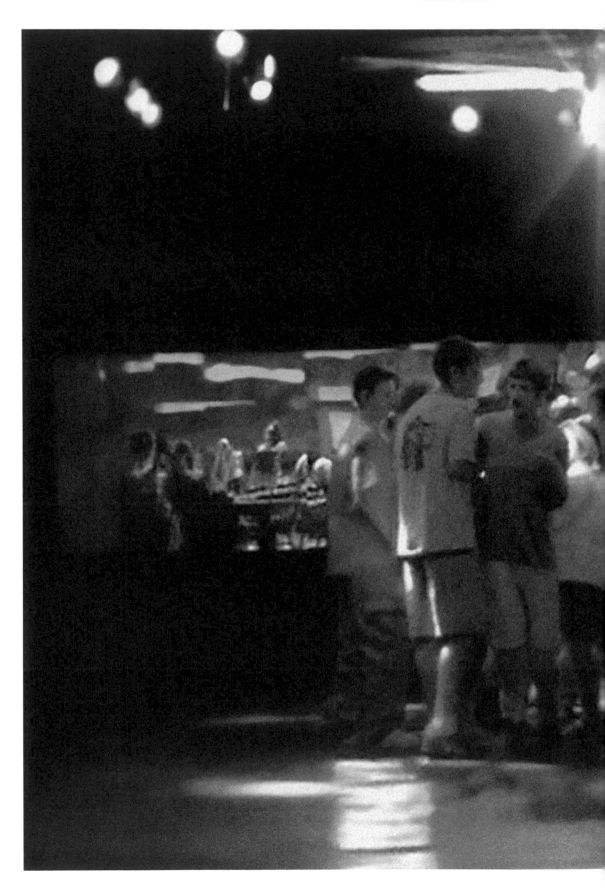

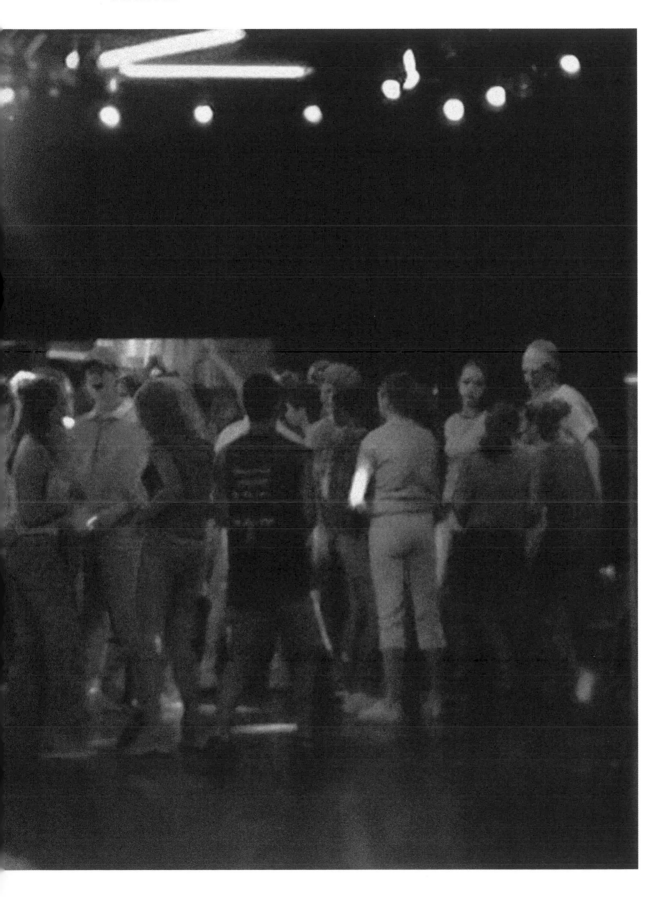

artist in the 1920s, when the idea of contributing to the construction of a new society by producing usable objects seemed to be a viable one.

Bustamante's objects since 1988, particularly *Intérieurs* and *Verre bleu*, the shape of which refers to the swimming pool in a 1981 *Tableau* (*T.42.81*), or *Inventaire*, are derived from various, mostly photographic models. As objects made in three dimensions, the photographed objects are removed from the space of their representation and transferred to a room which they share with the viewer, and the degree of reality is intensified—later Bustamante made several works in which he brought photographs together with three-dimensional objects, placing a picture flat on a low table, for example (various versions of *Ouverture*, 1993–94),

**Lumière 11.91
(Light 11.91)**, 1991
Ink on Plexiglas,
58 x 74 x 1 ¾ in.
(145 x 185 x 4.5 cm)

Des Limites, 1990
Colored cement,
60 x 30 x 1 ¾ in.
(150 x 75 x 4.5 cm)

thus creating a transition between photograph and object. The double bed, the interconnected bunk beds, and the children's cradle are clearly objects that exist in order to be used, furniture whose function it is to accommodate a body—not merely objects that serve some purpose, but those that surround the body, just as it is surrounded by a water-filled swimming pool. But Bustamante's *Intérieurs* and *Verre bleu* will never hold a body. They are irrevocably sealed and closed. The facing mirrors of *Inventaire* produce a short circuit of endless reflection. The evocation of the worldly function of these objects coexists with the total negation of its fulfillment.

In *Sites I–III*, Bustamante refers to one chief preoccupation of minimal art, the question of place—Andre considers "sculpture as place" to be the most highly developed position of a clearly organized history of sculpture. Through its form, materiality, color, size, situation, and so on, sculpture establishes its own "place" in the exhibition space, in relation to

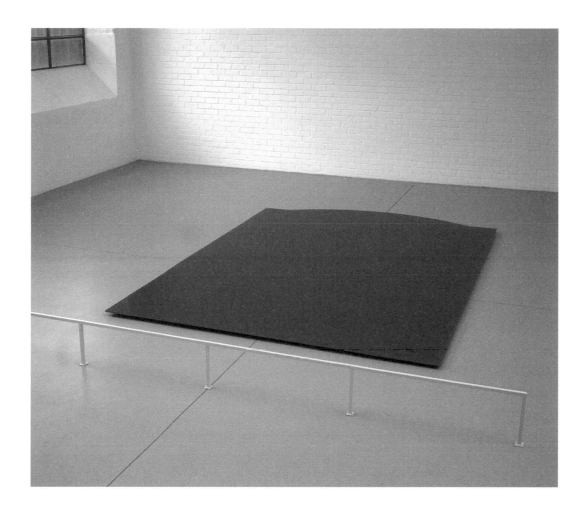

Le Verre bleu
(The Blue Glass), 1987
Painted glass,
11 ⅓ ft. x 8 ⅔ ft. x 1 ¼ in.
(340 x 260 x 3 cm)

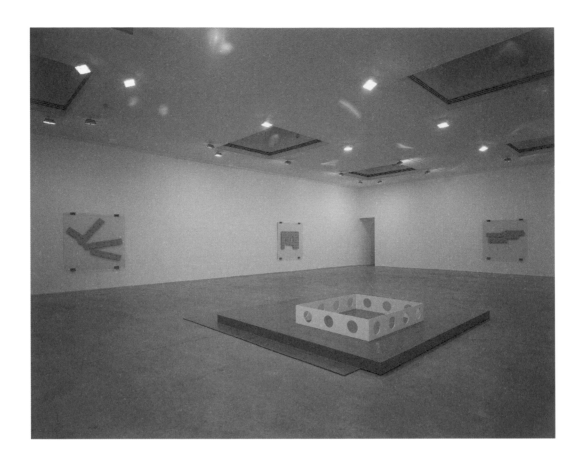

Site II, 1992
Steel, minium paint, lacquer, wax,
15 ¼ x 14 ⅓ x 1 ⅓ ft. (456 x 430 x 41 cm)

the concrete conditions of that space. Thus the concept of "sculpture as place" is closely related to the idea of the "site-specificity" of a sculptural work. The place of the sculpture is realized through the way in which a viewer relates to it. The *Sites* are large square metal platforms, irregularly coated with bright orange anti-rust paint. They cannot be walked upon, and each one supports a different white-painted object: three rods, a low barrier, an enclosure with holes in the side walls. The latter two objects in particular once again define their own place in relation to the platform. But what is crucially important for the (conceptual) position of the *Sites* is the fact that the objects are displaced from the clearly defined center of each platform, and two of the platforms are themselves displaced in relation to a base plate. Here, in the form of sculptural realization, we find a recurrence of the de-centered position that objects assume in the photographs—and the platforms, or plateaus, of the *Sites* are immediately recognizable as tables ("*tableaux*"). Just as *Paysage I* clearly reflects ("theorizes") the transparency of the photograph (its window-like character), the *Sites*, in their turn, display the particular site specificity of the objects in the photographed landscapes. The definition of place does not occur only within a given frame (the frame of the photograph), however, but refers to the work itself as a whole: in so far as the objects placed on the plateaus appear displaced in relation to the symmetrical platform, the platform itself must be seen as displaced in relation to the white objects. This means that the place that the platform (and thus the work as a whole) has been given in the exhibition space should be seen as ephemeral, transient, even displaced, whatever its concrete placement might be. So the work can never be "site specific" in the sense of having a firmly established relationship with the exhibition space, but rather forms its "own place" conditioned by an internal disposition to de-centering— compared to the sculptural strategies of minimal art, an independent and critical alternative to the modern concept of autonomy may be found in displacement as a constituent condition of the work. The fundamental displacement of the work, wherever it may be found, connects to the exclusion of the body. This is the twofold characteristic of the works with which Bustamante, in the late 1980s, critically engaged with the premises of minimal art, in order to return to the object.

Later works can be read as a continuation, reflection, and transformation of the de-centering of things (in the photographs) and the

constituent displacement of the work (for example in the *Sites*). Works entitled *Partition* (from 1996) are, like the *Lumières*, glass sheets fastened close to the wall, with metal plates fixed to them at irregular intervals with large machine screws—a peculiar contradiction in the use of material and technology, while the *Aquaramas* (from 1997) extend this form into the third dimension. The use of screws as a sculptural element goes back to *Paysage II* (1988), although in that instance the fastenings are applied in a regular series, and to *Les Oeillets*, a ready-made from 1988, which seems to reproduce the eyes of a human being. Once again, Bustamante's title provides the key: the screws are dots on the surface that draw the eye in a particular direction, and towards certain points chosen "at random" (on the glass sheet, on the wall). With these dots, which later recur as holes in works like *Paysage Zinc* (1991) and *Dispersion* (2002), Bustamante is staging that diversion of the eye, which occurs in the *Tableaux* under the conditions of representation.

On the other hand, Bustamante's sculptural practice of constituting the "place of the work" (Alain Cueff) in the form of *Sites* (there is also a

Dispersion II, 2003
Ink on Plexiglas; five elements, each
88 x 24 x ½ in. (220 x 40 x 1 cm)

fourth work from 1992 with that title: three stretches of fabric extending from the ceiling to the floor and covering a strip of the floor, fastened next to the wall-like curtains and held down to the floor with white-painted rods that connect the three elements) or the *Verre bleu* (1988) or the two versions of the *Bac-à-sable* (1990), is expanded and reformulated in flat, horizontally, or vertically placed sculptures of painted steel or glass (painted on the front or back), or PVC, with titles like *Origines*, *Les Autres*, *Leda* (all 1992), or *Continents* from 1993. With the title *Continents*, Bustamante gives concrete shape to the concept of the place of the work: no longer a place in general (*Site*), but a geographical place (even if the geographical definition of the place remains very general). The concretization of the place is expressed in the fact that the form chosen for

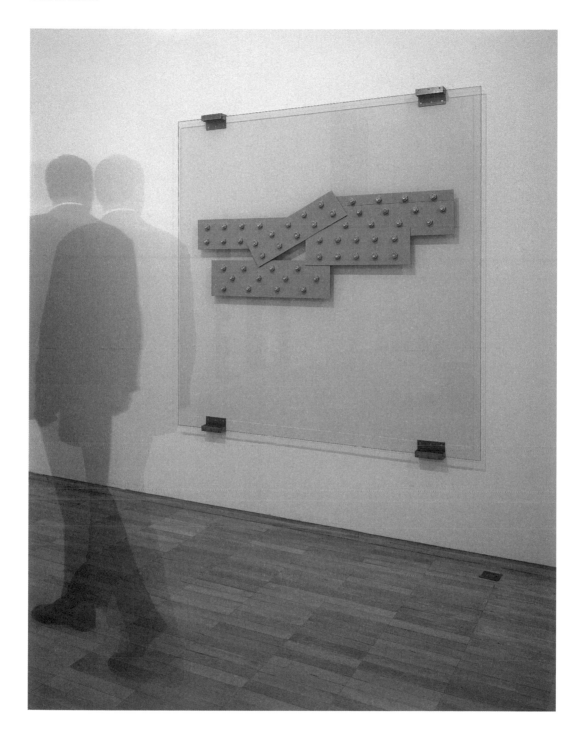

Partition I, 1996
Painted metal, glass,
70 x 68 in. (1.75 x 1.7 m)

the outline of the place-forming sculptures is not geometrical but irregular and organic: on the basis of a free drawing from Bustamante's hand, the constituent displacement of the *Sites* is transformed into the irregular boundaries of a flat and extended piece of material. The most fully developed form of the free and irregular outlines (and at the same time an anticipation of the punctuations in the later works) is apparent in *Arbres de Noël* from 1994–96. With de-centered punctuations and irregular outlines, Bustamante, under the condition of the "abstraction," emphasizes the defocusing of the gaze, the paradigm of which is found in the *Tableaux.*

One further element of Bustamante's deconstruction of the minimalist object, along with the exclusion of the body and the

**Sans titre
(Untitled, diptych)**, 1993
Steel, paint; each element
82 ½ x 53 ½ x ½ in.
(206 x 134 x 1 cm)

displacement of the work, is the return of the hand. Large metal plates or sheets of glass with irregular outlines, and titles referring to Christmas trees and continents, are a medium for the return of the random movements of the hand, which generations of artists had fought to eliminate, to his work. The return of the hand also informs the *Panoramas* (from 1998), silk screen on Plexiglas, which derive from simple drawings by Bustamante, arrangements of lines that recall the scribbles of children. Mediated in this way, the return of the hand is not inconsistent with the exclusion of the body: it represents the acknowledgement of the personal in the production of a work of art, without reversing the banishment of the subject from the central position of perception.

In his works since about 1992, Bustamente has had less to do with the concretization of the object than with the development of new and different forms of shaping the exclusion of the body, the de-centering of objects and the displacement of the work. The work becomes "theoretical." This "theorizing" is accompanied by a peculiar "return of the hand" in the form of free drawings that are mediated in different ways (craftsmanlike, mechanically, through reproduction). We might even ask whether the

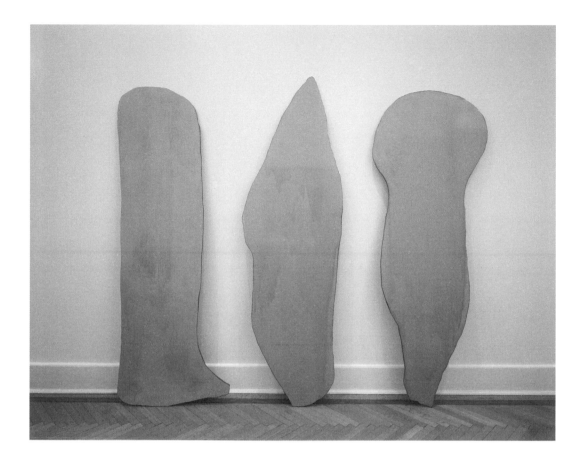

Sans titre (Untitled, triptych), 1993
Steel, paint, varnish; each element
77 ½ x 28 x ½ in. (194 x 70 x 1 cm)

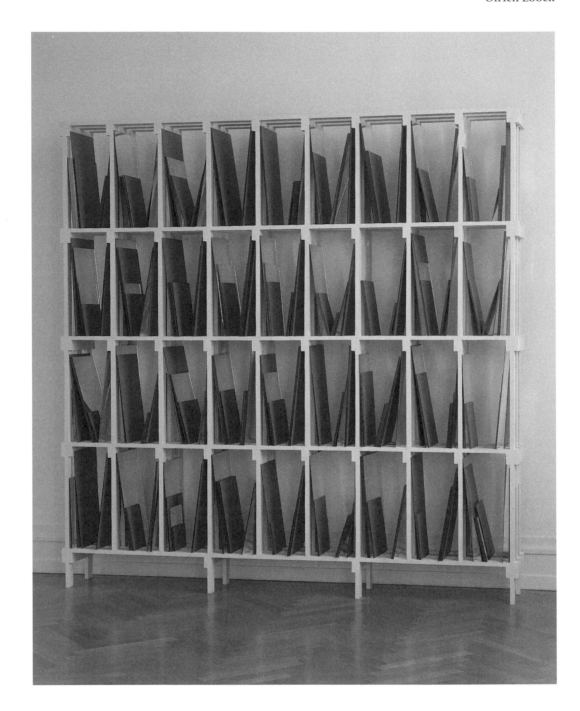

Inventaire, 1989
Wood, mirrors,
8 ¾ x 8 ½ x 1 ⅛ ft.
(262 x 254 x 32 cm)

"theorization" of the work is not precisely the condition that allows the hand and, with it, something personal back into the work. This personal aspect complements and interprets the being-themselves of the objects in the *Tableaux*. The acknowledgment of the personal is probably Bustamante's greatest achievement since he found ways to bring about the return of the object—if his early objects were not themselves personally informed. In connection with the region where he photographed the *Tableaux*, Bustamante himself brought his childhood in Toulouse and his early familiarity with the material nature of that area into play, and the reference to the cradle, the beds of the adolescents, and the double bed, or the reference to the sandbox, have a more intimate and worldly character than may at first have been apparent.

Conversation between
Jean-Marc Bustamante, Christine Macel, and Xavier Veilhan

Recorded on March 25, 2004,
at the Annexe restaurant, Paris

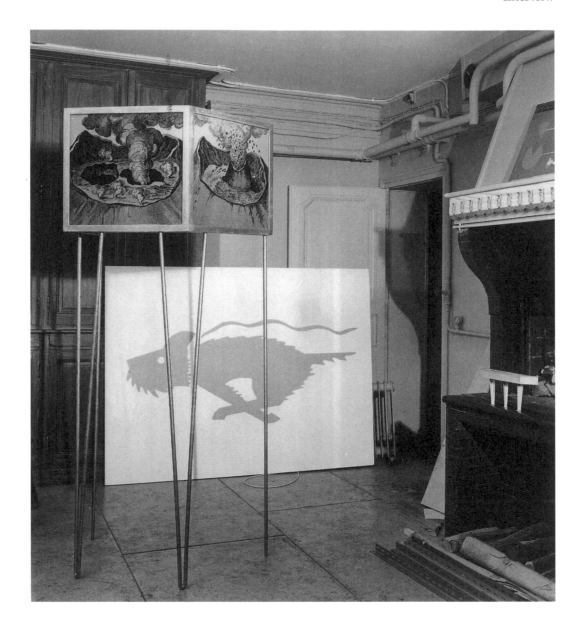

BAZILEBUSTAMANTE
Studio view, 1985

[Christine Macel] How did it start for you, Jean-Marc?

[Jean-Marc Bustamante] Above and beyond any real commitment, the point was to get to an open situation, and improve working conditions and visibility. In my case, this first took place in Belgium, at Antwerp and Ghent, at Joost Declercq's gallery, then at the Galerie Nelson at Villeurbanne, which had begun to show interesting artists of my generation, from Tony Cragg to Reinhard Mucha. Directors of museums and institutions were just as important, such as Ulrich Loock in Bern, Julian Heynen in Krefeld, and Jan Debbaut in Eindhoven—not forgetting the perspicacious and experimental Suzanne Pagé in Paris.

[CM] And you, Xavier, could you follow all this from Lyon?

[Xavier Veilhan] No, not from Lyon. I got interested once I'd arrived in Paris. There was a kind of network; we talked about it recently with Franck Scurti. Bazile, Bustamante, were the artists we—François Curlet, Franck Scurti, Pierre Bismuth, Pierre Huyghe, and me, and perhaps two or three others of my generation—followed the most closely.

[CM] Philippe Parreno, for example?

[XV] At the time there really were young artists with links to older ones such as Alain Séchas, Jean-Marc Bustamante, and Bernard Bazile, and also Daniel Buren.

[CM] You were a student of Daniel Buren's weren't you?

[XV] When I was at the Institut des Hautes Études in Paris, I was, yes. All he did was ask me three questions and tear me to pieces!

[CM] I suggested to Jean-Marc that perhaps Tobias Rehberger, Jorge Pardo, and Liam Gillick were a bit like Buren's sons—we could put you in the same gang. I'd say that you're Bustamante and Buren's nephews [XV concurs]. Besides, it seems to me that there are links between the work of Jean-Marc, of Jorge Pardo, and even of younger artists such as Gary Webb. [to JMB] Do you accept your "uncle" role?

[JMB] Well, family ties are always reassuring. I belonged to a group, together with Jan Vercruysse, Juan Muñoz, and later Franz West, that was very active in Germany and Holland. We showed in Krefeld, Antwerp, and Eindhoven. The group was rather thrown together; when you look at our various works, they come from very different worlds. Even then people said: these artists are working on furniture—even at that time! All because there were fireplaces, chairs; Thomas Schütte made models of sorts. It was at that juncture that the concept of object was being reactivated, shortly after conceptual art that had excluded it. Even the first exhibitions with Bazile were like that: "Francis Ford Coppola" was a way of reverting to conceptual ideas embodied in the object. We had got going again thanks to Richard Artschwager's career, who'd been a bit forgotten.

[XV] The reconciliation was centered on a strong drive for form, between a pop dimension and conceptual art.

[CM] It wasn't IFP.[1]

[JMB] No, not at all, because IFP was simply an extension of conceptual art. The important thing for us was to open up a breach between a decadent post-*nouveau réalisme* and a highly ideological and disembodied conceptual art.

[XV] To return to the question of genealogy, I think my relationship with the work of Jean-Marc, Daniel Buren, and Bertrand Lavier is characterized by formal affinities and common interests.

[CM] Not necessarily in the works. I also meant in intellectual terms.

[XV] My ties with Jean-Marc are also on the level of his moves to achieve international recognition. Today, for example, Bazile's work doesn't interest me anymore, whereas I still respect Daniel Buren's. He's the only artist of his generation to have really made the effort to get out, to make things. He blazed the trail.

[JMB] Yes, that determination to go and conquer new territories.

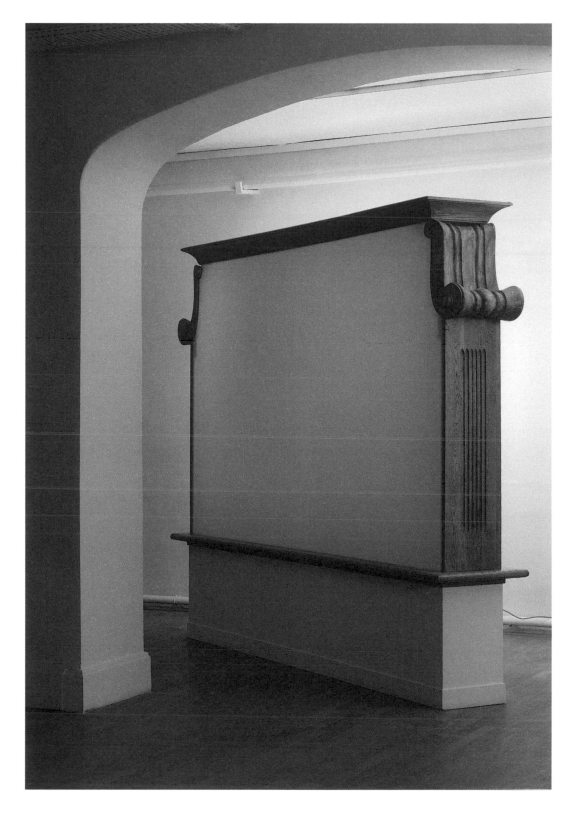

BAZILEBUSTAMANTE
Sans titre (Untitled), 1985
Wood, Plexiglas,
11 ⅓ x 9 ⅓ x 1 ⅔ ft. (340 x 280 x 50 cm)

[XV] It's not only the conquest, it's the generosity, too.

[JMB] A time comes when you have to let go of your comfortable references and look elsewhere. That's what's called generosity, or curiosity, the courage to move on, to have the humility to say that you've got to get off your little pedestal, that you can't look down at the world from your balcony anymore and only think about art on art. French artists are the best commentators on art and certainly the worst artists. That was the problem with Bazile at the time. He didn't want to move anymore. He said, it's not worthwhile producing too much, one's developed a system, one's found something, one's got a theory that works, and one can just stop there. The generosity you mentioned is exactly that ability to say to yourself, I can smash all that up.

[CM] It's also called modesty.

[XV] Modesty and ambition.

[CM] But ambition comes from the awareness of everything you might still become.

[XV] That's true. It's also a kind of confidence with respect to objects. There comes a time when you say to yourself: I'm within a framework, I produce works, and the anchor point of this system is formed by pieces I'm going to show in various venues. It's not an easy thing to do, but it has to be done.

[CM] You're really talking about voluntarism.

[XV] More especially about a process which—without being "American" and directed towards the concept of the object—consists in saying: we are the bearers of these objects and it's our responsibility to put them in such and such a place, to make them active.

CM] In a way, you don't completely let the object go when it leaves the studio, you accompany it until it's exhibited. [*to JMB*] That's not your approach.

[JMB] No, ambition as you call it is just asking for that little bit more. I could just as well have not budged from photography. I knew I was ahead of the game with the photographic pictures; I'd taken the risk to configure photography as an object. Nobody had made photographs like that, in color and in such a large format. What happened thereafter is well-documented. I'd discovered something essential that allowed photography to exist fully in the art field. I didn't run with it, though. I preferred to continue developing an individual body of work that presented the image as the model, in a mix of media. In terms of photography, everything has changed.

[XV and CM] Just a bit! [*Laughter.*]

[JMB] And it's true that if I'd remained in photography, I'd have been less problematic than I've become, I'd have been better known than I am, much richer, too, but I reckon I'd have been much less satisfied. I've the impression that what I've reached with my inquisitiveness—abandoning the camera and attacking the third dimension, the object—greatly adds to my work's potential. It's more ambitious than a photographer inventing the photographic picture and then spends his whole life putting it through its paces.

[CM] What strikes me, Jean-Marc, and we talked about it a few moments ago when referring to your natural sense of strategy, which we'd like to have a bit of, is that even at thirty it seemed you already had a vision in time—or perhaps you reconstituted it a posteriori,—already had a way of projecting yourself into the future, and this in spite of the angst of daily life, it allowed you to hold on to your positions, on occasion looking a bit like a tightrope walker.

[JMB] I don't know what I can say in response to that. At a given time, you're buoyed up by this research, you feed into things crosswise—say, the relationship between sculpture and photography; you cherish a boundless love for art and for the artists you see around you, you want to measure yourself against artists as diverse as Bruce Nauman and Joseph Beuys. I remember once finding myself in Brice Marden's studio in New York and, standing in front of his pictures, tears welled in my eyes.

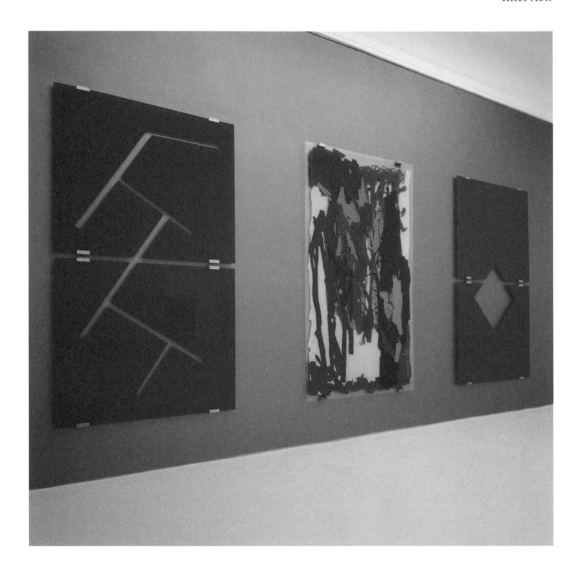

**Panorama From Here
to There**, 2003
Ink on Plexiglas (triptych),
20 ft. x 11 ⅓ ft. x 2 ½ in.
(600 x 340 x 6 cm)
Central panel: 11 ⅓ x 6 ⅓ ft.
(3.4 x 1.9 m)
Side panels: 5 ½ x 6 ⅓ ft.
(1.67 x 1.9 m)

That completely cured me of all the narcissistic stories of an art standing before its own mirror, which mediocre artists peddle, that reflects ad infinitum the distorted image of an art just peering at itself forever, and which is of absolutely no interest to anyone anymore. I belong to a generation for whom a theory preliminary to the work existed; it was highly standardized. It was the Bechers, it was Buren. It was the Buren of some time ago. And in fact there was already talk of Daniel Buren's generosity, and I know many collectors who maintain that Buren betrayed them. They reckon it's just decoration. It's not that. He simply dared.

[xv] When I was at the Institut, I think Buren was in the very delicate position of a sniper smack in the middle of the system. There are guerillas who try to demolish a system of thought from outside. Buren simply shot himself in the foot. There was an interval in which he didn't take on the visual effectiveness of his own work, which is very great. His approach in the *Les Deux Plateaux* at the Palais Royal already tended to be more relaxed. What was brilliant in my eyes in his show at the Centre Pompidou[2] was that suddenly he completely assumed his position of strength with respect to the French establishment, and I know it's no easy task to carry this off against such a backdrop. He staged an enormous, formally rounded exhibition, truly "general public," and—most of all—it was all very joyous.

[cm] It's funny, because it was at this time, between this exhibition, Jean-Marc's pavilion in Venice, and the fact that you [to xv] also had an exhibition at the Centre Pompidou[3] that the family tree we were talking about a few minutes ago came into play. There's one thing that strikes me a lot in both your careers, and it's the fact that the reception of your work is all the more problematic because you never stick with one style. You are always in a dialectic. You [jmb], with the sculptures/*tableaux,* for example, and you [xv], with regard to your three-dimensional sculptures and pieces. I feel that this destabilizes the audience, which says, either it's too much or it's not enough.

[xv] Even I'm getting lost now. A public *and* a market!

[JMB] Above all, a market. It's incredible sometimes to note the extent to which the market is preprogrammed, especially as today prices are extremely high. When you try to open up, when you refuse to get typecast by just one style, then you're in league with time against the spirit [of the market], because, fundamentally, you trust in time.

[CM] I'd say in experimentation, rather. Perhaps you stop experimenting the moment you redo the same type of photograph for the hundredth time.

[JMB] True. That's not particularly interesting. What's exciting is to make people afraid and give them pleasure at the same time. My upcoming projects are intended to get the world I've opted to build to come across more and more clearly, or rather to share my vision of it. A certain feeling for the world, at the same time sensitive and spectacular, insignificant and terribly highly charged, searching out an unstable equilibrium, like a tightrope walker, just as you said. Useless and miraculous. Radiant. The project I'm developing for the museum at Bregenz[4] will allow me to work in this direction, to set up new pieces, new sculptures over three thousand square meters, in total freedom and with every means necessary. To try to make things clearer, more luminous, more fiery too, all by making them denser.

[CM] And more opaque, perhaps! I think of the piece you showed me, a metal cutout through which can be seen a painting on Plexiglas, a hybridized sculpture [*Beau Fixe*, 2004].

[JMB] You shuffle the cards differently, you deal them out again, and you watch just how the obsessions come out.

[CM] You work like that, Xavier.

[JMB] Obsessions are always more or less the same, so other solutions have to be tried out.

[XV] Jean-Marc's work is three-dimensional, not that it's sculpture, it's the project that is three-dimensional. That's to say that it deals with a total

object, where works that are also planar elements build into a general form. That's what also interested me so much with Bazile and Bustamante: it was a multifaceted object. And there are artists who are vertical; they make a hole, they do a line. Then there are artists who are on the surface and those who are in development, who experiment. If it all works out well, at the end you obtain a much richer form than by the simple addition of facets.

[CM] A Rubik's Cube.

[JMB] I really like the image of the soufflé. You try to get it to rise. There are certainly many things for me to do and I'm sure the best is to come; then I'd like to try out the missing things—but if this were all to grind to a halt, it wouldn't be too serious, as everything was already in my earliest photographs. The pieces I make are not fragments of a future work; it's not a jigsaw puzzle. I put great store by early works and by works of old age. They're the freshest.

[XV] If you'd carried on doing the photographic work you talked about a moment back, you could have covered more surface, but it would have remained on the plane. Sometimes artists appear and you say to yourself, it is very interesting, but in five years. . . . Then you realize that at root that's not their ambition. The pieces can be very good, but the project isn't.

[JMB] You can take a narrow path—or be Morandi, Mondrian, and have a vision. You don't have to get into multimedia to have a vision. The problem isn't to stick to one medium or to use five, it's to feel in an artist's work that there's a development, whatever the restrictions might be. Then he can get by without a mass of stuff. I don't much like the term "project," or "program." The artist must have a unique vision.

[CM] Yes, what you're saying, and it's crucial, is that you have to have a vision and not just ideas.

[JMB] For the amateur and for the informed viewer alike, it can be very hard to perceive or get a hold of a vision. In the best case scenario, the artist is presented with a circuit, with infrastructures more or less adapted

to getting his work distributed, but these networks are distorted by an often perverse market. The artist has to make do. It's up to him to thwart its traps and turn them to his advantage.

[CM] Your vocabulary's very....

[XV] Marketing?

[CM] Masculine rather. You're talking about something that's like a battle, where you have to carry a big stick. I'm not saying this as a woman, but I ask myself if it's the same thing for women. And I ask myself the question all the more urgently as few women keep going for more than ten years.

[JMB] They find it tough to stay the course, often preferring to develop a radical and effective system. With Nan Goldin, Cindy Sherman, everything was set up really quickly and after that they hardly shifted.

[CM] Do you have any idea why? Why is it one sees men—I'm thinking of Thomas Hirschhorn and of you two—who work with a kind of super-energy. You produce a lot, you experiment in various dimensions, there's a kind of flow. I wondered recently why this isn't the case among women. You described it very well with the idea of line.

[JMB] Yes, a man needs to conquer territories; a woman finds her territory and stays there [*xv and CM are skeptical*]. Whereas women seek a man, a man wants all women. A woman, as soon as she's found her territory, remains there, from Agnes Martin to Tracey Emin. Men are always on a search for virgin territories.

[CM] I must be a man! But it's true that there's no dispersion among women.

Preceding double page
Panorama Surroundings, 1998
Ink on Plexiglas,
62 ¾ x 96 x 1 ½ in.
(157 x 240 x 4 cm)

[JMB] Men take far greater risks, like being hated, being polemical, spending a long stretch in the wilderness.

[CM] A female Maurizio Cattelan would hardly be likely, for example?

[XV] For my part, I'd like to see a female Carl Andre. By constituting a more authoritative artistic figure, by imposing radical forms, she'd offer an interesting alternative to those women artists who retrench to their preassigned social box.

[CM] In point of fact, you're confirming my worst suspicions and that makes me depressed! Today, I'm doing an exhibition without a single woman for that very reason. I didn't find one woman who could be compared with the other artists, and I'd prefer not to include them rather than respect the quotas.

[JMB] The theme of your exhibition *Dionysiac*[5] is made for men—so you can hardly be very surprised! You've invited a horde of barbarians to fill the spaces of the Centre Pompidou: they're conqueror-artists. Women artists occupy other superficially calmer, but just as essential fields, as they've proved. [Silence] And Louise Bourgeois, where's she in all this?

[CM] I like her a lot. She is a species of "phallic woman."

[XV] And in crochet to boot! Fifteen years ago, a kind of "Louise Bourgeois" syndrome broke out. Little ditties, drawings, huge sculptures, and crocheting; that was a bit like the kind of work you came across in art school. And when you said, "It's not up to much," to the person who did it and who happened to be a girl, she'd answer: "Ah, you can't say that because it's personal."

[CM] Yes, but you have to take on board one thing: women have only very recently been able to express themselves as artists, from the 1970s on. Before that, it was hardly possible.

[JMB] Their recognition was built on the problems of society; their work had a subject. Not so with men. There's no real subject in Xavier's work or in mine. Among women, the subject of their liberation got the better of them. Rosemarie Trockel is a symptomatic artist. Her earliest pieces were knitting-based; then her work became increasingly complicated, and today it is really significant. She just has to conquer a true form. When will there be formalist female artists?

[CM] Let's let women be. I'm thinking now of something you have in common: you do a lot sculptures in public spaces. Well, with you [JMB] it's more recent.

[XV] It's recent for me, too!

[JMB] The thing is to have a finger in every pie, that's the challenge. I've seldom seen a public sculpture that works.

[CM] Could you tell us a bit about your most recent project of this kind? It occupies, it seems to me, a very special place in your oeuvre, in that it marries the cages, the organic sculptures like those you'd done with *Serena* at the Kröller-Müller Museum in Oterloo, and even the sculptures with holes. It's possible to see through them.

[JMB] Yes, I'm working at the moment on a large cage, made of bent metal, a touch baroque, a bit ugly, held in place with lead fixings. It is a place in itself, like a big television screen where the image comes out of the screen. It combines obsessions I've always had. The relation between the geometric and the organic, between drawing and space. I always draw on graph paper, for instance. I find it inordinately hard to draw on blank paper.

[CM] Why's that?

[JMB] Graph paper is a structure. All the drawings, all the panoramas I make have always been on graph paper, brown or blue. For the large sculptures I've been making, the ground is like graph paper. It's a structure, it's as if there was an order and that you're trying to get

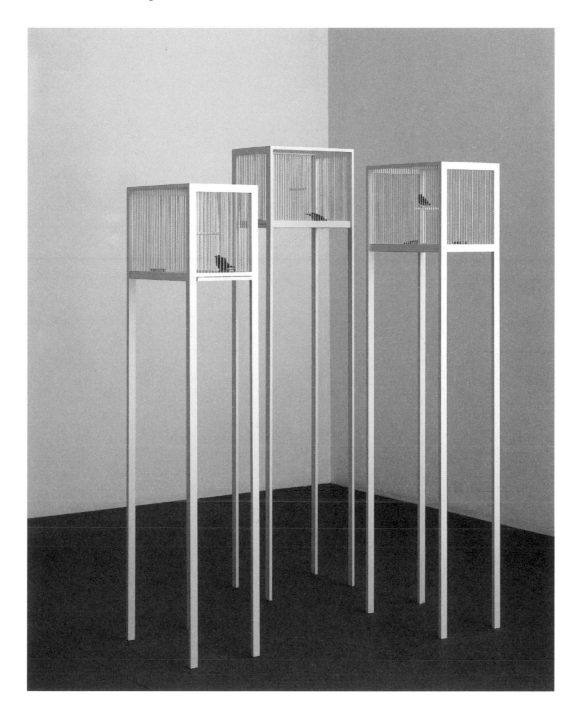

Suspension, 1997
Painted metal and live finches
(diamond mandarins),
78 x 12 x 18 ½ in. (195 x 30 x 46 cm)
74 x 12 x 18 ½ in. (185 x 30 x 46 cm)
70 x 12 x 18 ½ in. (175 x 30 x 46 cm)

disorder and order to coexist. It's not a question of destroying order, but of both coexisting. And what I'd done in the Kröller-Müller, taking the architecture of the house built by Rietveld and sticking a two hundred and fifty meter-long pipe through the walls of the structure and out into the park—that was keeping an existence going. I think this also derives from my coming from photography, from always starting with a reality. Graph paper, the museum wall, is a way of holding on to an architecture. The camera being of itself an architecture, onto which you place your photographic plate.

[CM] You always go from the two-dimensional to the three-dimensional, then.

[JMB] Yes, I could never show these drawings as drawings. They're drawings made as if in three dimensions. I think of the Plexiglas, of the wall behind which the piece is revealed, of the supports that will put the piece in space for you.

[XV] It's also pretty symmetrical with the photographic work, as with the hedges of cypress.

[JMB] Once again, there are curtains screening the scene—just as in the *Lumières*, the black and white of the loci of memory are disclosed by the Plexiglas and the wall. These aren't photographs on paper any longer, it's space in a space, an emerging world. I think it all comes from photography. In the same manner, the white cages with the bird inside are like a photographic chamber. Many works of mine concern enclosure, but they're symptoms. It helps the work, but it shouldn't be too obvious.

[CM] Xavier, we said a few moments ago that you'd been very influenced by Bazile and Bustamante. Did that also influence your conception of your work, in the idea of working together? Because working with others is something you talk about a lot.

[XV] Not that much, because it's a natural need. If I was in another trade, I would just have to work with other people.

[CM] Unlike Jean-Marc, you've never done a two-handed piece.

[XV] No, and I've been involved in very few collaborations. But I've just done something of the kind with the Model T Ford. Pierre Huyghe did one in ice (*Leisure Line*, 2004). When I made the first Model T Ford in France, he filmed its manufacture in France, and he also filmed it in China; perhaps he'll make a work about it in film form. But this collaboration is in inverse proportion to our proximity in space. For years, we worked in the same room; we were in each other's pockets. We talked about work all the time, but we came up with distinct formal solutions. For example, I did do "Ann Lee," but I was in it from A to Z. Beyond the genuine interest you might have for certain works, or for the impact they make, many people interest me, and by being in this business I've been lucky enough to meet them. Like, for instance, taking the bus from Slovenia and Venice seated between Robert Morris and Allen Ruppersberg, of whom I'm a fan.

[CM] That's funny. Cattelan wanted to be in art because he thought it was all women and dollars.

[JMB] I wanted to be a rock musician. I did lot of mileage on the concert circuit. I hitchhiked from Toulouse to the Isle of Wight festival in 1970, the Doors, Jim Morrison, Jimi Hendrix. . . . This terrible competition between artists also exists in contemporary art. But over time it sorts itself out, one feels more at ease, it becomes easier. I remember, ten or fifteen years ago, the quarrels between the Bazile clan and the Bustamante clan. It became a bit complicated.

[CM] What did you want to do? [*to XV*]

[XV] Me? When I was little, I wanted to be a vet. After that, I didn't want to do anything at all. But the fascination music exerts. . . . Often, you can feel something physical with music, it sends a shiver down you, you cry. Sometimes with electronic music, you're in a room with five hundred people, something flows, you listen, and you get the impression you're on a flying carpet. You never get that in a museum or a gallery.

[CM] Yes. It can happen, but it's not necessarily the goal.

[JMB] It's very rare, but that's not the problem. What I've got against cinema is that it grips you physically, really strongly. I always thought that it's either too much or not enough. The withdrawal you experience before an object, you're there, it resists, you like it, you don't like it. After that, it has a much greater effect on you.

[CM] Yes, I like that distance.

[XV] But the impact's different!

[JMB] Quite right. The impact of music. . . . It's overwhelming. When you're a rock musician, you are from head to toe.

[XV] Yes, but the memory works more effectively with visual things than with music. For instance, I walked past Warhol's camouflage-pictures. For a long time after, a kind of trace lingers on, something really strong that's still evolving.

[CM] It's probably got to do with the fact that, in your brain, you think in abstract forms, and not in sounds.

[XV] You don't think in terms of time, either. Music is time.

[CM] You can, for example, memorize an image, recreate it in your mind, and look at it again, whereas it's really hard to get back the feeling you had in a concert. You just have to listen to the music again.

[XV] Yes, but one's remembrance of a piece, or of a moment, is scarcely accurate.

[CM] I think that fact that an art object is also an object of a phantasm is important. You see it, then you think about it again when you can't see it anymore. It's something that is replayed within the phantasm. It's very important for the visual arts.

L.P.I, 2000
Color photograph,
90 ¾ x 72 in. (2.27 x 1.8 m)

[JMB] Yes, this is why I believe in what I call the the mental state. That's the reason you remember a live show much better than a film. The physical presence of an object is equivalent to a body. When I first saw the Living Theater in Toulouse on stage, it struck me ten times harder than a lot of other things based on imagery. That's why right away I had real problems with photography. I wanted to make an object, a picture, because an image for the sake of an image was never enough for me. Likewise, I've never made a video, because I need greater physicality, I have to be there.

[CM] It's a point you've got in common. But with some video work you get this type of relationship. Between sound and image, you're in a physical space which goes beyond the purely visual.

[XV] What's interesting is that this physicality can be found in the cinema, where time is treated like an object.

[CM] What Jean-Marc is saying is that when you're in front of an installation, you come with your body, and therefore you can have a physical experience if the image around you urges you to do so, if it's not treated like a film. On the other hand, when you're in the cinema, you're in a state of low motivity, that's the whole thing with the movies. You sit and your body no longer functions, you're neurobiologically situated in an emotional sphere. That's why it's so hard to remember a film accurately. You're so into the emotional that, when you leave, it's difficult to remember the sequence of the shots and the images.

[end of the tape]

[CM] You've talked about the scene in the film *Caro Diario* where Nanni Moretti goes to Pasolini's tomb by scooter.

[XV] It's a traveling shot, I think it's got to last about two minutes. Moretti puts you in a situation where the material thing is not the image you see but the passing of time. You feel it's long and at the same time it's brilliant. It's like when you're listening to some music and you're interested solely in the materiality of the sound. Like a long drawn-out chord. It's hard to do this otherwise than in the cinema.

[CM] When you make films and you retranscribe them in quasi-digital form in "Light Machine," it's much the same. You deconstruct the film [and] that makes it physical, sculptural. Just as when you do photography, in fact you produce photo-sculptures. For example, the sanding process used making your photographs on Dibond is a sculpture technique.

[XV] Yes, but it's photography too. That said, it's very interesting to examine a negative under a magnifier. There are contour lines between various colors that react chemically. The film possesses a thickness; layers of chemical attacked by light in different ways, depending on the colors.

[CM] What strikes me is rather the sculptural idea of *reserve*, one we find in your work, Jean-Marc.

[JMB] I like it when the reserve is space. It's not materialized. It's light, space, the void, air. The films that grab me are those that become objects, like a Cassavetes film, or certain Godard films. You remember them like objects. Then there's your identification with the characters, a relation to time, as in *La Notte*, or with Antonioni's films. What you remember is the passage of time.

[XV] There are also films outside the history of "noble" cinema that have marked me, like Paul Verhoeven, Michael Mann. . . .

[JMB] What's interesting is when you see a film and you're bored to tears. You say to yourself, it's no good, but I'll stick with it. It happened to me with Wong Kar-Wai's last film, *2046*, I was a little bored, but now I reckon it was really good. Nonetheless, the film is a bit long. And then it forms a sediment, it stratifies, one level after the other. It's the thing with the soufflé, the story of a work. I'd want people to react like that to my work— not that my invention is so extraordinary, not that the work's so dazzling—but I'd like them to see it as something different.

[XV] I like the idea of the soufflé; it goes back to what you said about emptiness. They're bubbles.

[JMB] For instance, I like being surprised by artists who confront me with problems.

[CM] That's exactly what I liked about Jean-Marc Bustamante. He'd put a problem before me.

[JMB] Afterwards, you reflect on it, you say to yourself, in the end, it's not so bad; and this attitude ends up very enriching. In the same way, falling in love with somebody gradually is sometimes more extraordinary than love at first sight. You see somebody, then you see them again, and you don't like them that much, then suddenly it grows. The same thing occurs with spaces, with places. What I liked about doing photography at the time was stopping my car at a place where there was nothing, but that was sufficiently attractive for me to think it was worth taking a photograph. Then I got out of my car and looked. And I said to myself, now let's make a photograph with this nothing. There were only a few trees, a patch of earth, a house under construction behind, and so on. It was extraordinary for me to make all that into a picture. To make, from this nothing, an icon, a unique picture in which the subject would be unimportant. It was a challenge for me. And I was a little saddened to see later that contemporary photography was done on very different bases. It's a pity, I think, that Thomas Struth is known only for his photographs of church interiors and jungles, that Andreas Gursky is known only for his photos of stock exchanges and Prada. The subject becomes central, whereas what's interesting is to have a personal vision, an eye that makes what you recreate with the real stronger than your subject. It's not always the case in the "plastic" photography of these last few years that acknowledges a perfect mimetism with late nineteenth-century *art pompier*— it's a pity.

[XV] That's what I liked so much about your series of photos of Switzerland and Japan: in particular, the photo with a lopped-off trunk, a photo of a tree without a tree.

[JMB] Yes, that belongs to the series on the Swiss lakes. You just don't make a hierarchy in the subjects. I did it on purpose, a little perversely. The lake there was splendid. Ten centimeters of it appear in the image, magnificent

T.3.79, 1979
Color photograph,
41 ¼ x 52 in. (1.03 x 1.3 m)

and radiant, and I moved it. It's very interesting to work like that. I think it's a pity that there aren't more artists, photographers, working reality, so as to show the world differently.

[CM] The bland, you mean?

[JMB] Wolfgang Tillmans, for example, is really good at that. I like his work because it succeeds in revealing the everyday in another manner.

[CM] Talking about you, people always mention the idea of images "without quality." In what way do you think you've made use of Robert Musil's ideas?[6] He did, for instance, try to develop the idea of the possible, as against the probable.

[JMB] One might say, it could happen. The worst is never certain. I like moments in abeyance.

[CM] A skeptical position, all in all.

[JMB] I can't stand skeptics.

[CM] It's a way of protecting oneself against possible disappointment.

[JMB] Those who preach about art, the theorists, offer solutions, as if there were just one. Nothing is less normative than art. And when I speak about an absence of qualities, I like paltry little things, things that lack something.

[M] In fact, you don't like spectacular things.

[XV] But you do like Tony Smith, for example.

[JMB] I adore Jeff Koons, too! For instance, his chrome-plated balloon dog is dazzling. He hadn't anything more to say after that.

[XV] The rabbit, too. But there, the relationship is more with the instant. There are works like that where the present moment isn't the point;

there's the moment before and the moment after—just the opposite of music. That's what I'd like to be able to do: to dematerialize a moment. It isn't a moment anymore; it's a trail, a visual impact.

[CM] In fact, you want things to live on in the memory, rather than just in the instant of their physical reception.

[XV] Yes, for Jean-Marc, as for me, many pieces exist that are like kinds of prefabricated memories we've tried to synthesize as a vision, a dream. In these images there's neither more nor less than what's needed to reconstitute this impression.

[CM] I've a question concerning this search, or not, for the spectacular: to what extent is it desirable, with respect to all the abuses of it within the area of *entertainment*? Don't you think that there's a paradox in those artists who say they're trying to avoid the spectacular, an over-immediate effect? Not for moral reasons, but because they think that if the immediate effect is very strong, it'll wear thin, so it's better to be more discreet. At the same time, when you look at Disney images like Mickey Mouse, et cetera, it's very immediate and yet it stays with one all the same.

[JMB] There's no truth. There's no dogmatism about this, whether you take a rather deceptive path, like mine, or operate by assertion, like Jeff Koons. I make drab little photographs, a little improbable perhaps, but I like that.

[CM] Now, you're exaggerating. . . . It's a rather "hi-falutin'" drabness, not "gutter" drabness!

[JMB] Yes, but it's not the assertion of a position. You're there and you say, I like that, I don't like that, you walk around it, you're not at all sure, it doesn't hit you right away, like a Koons. Bang! That's not an effect I'm looking for, but I like to see it.

[XV] What I notice more in your work is the way it occasionally starts out from an tiny postulate, but is put in a situation where it acquires such authority that you just cannot pass it by.

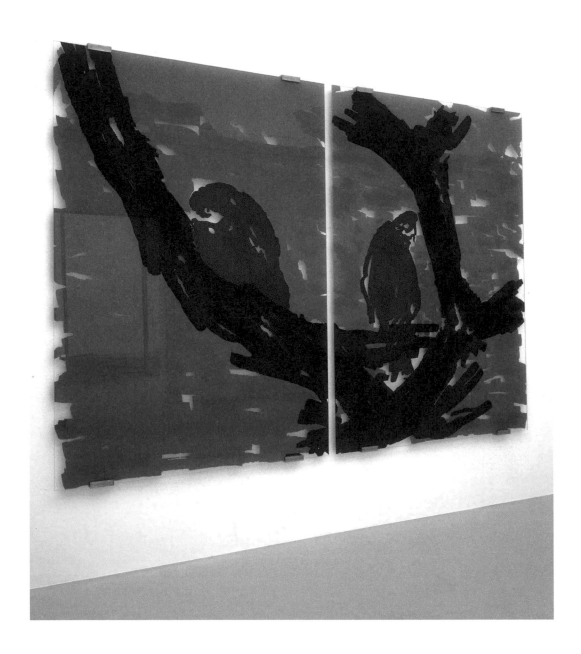

**Panorama Perroquets
(Parrot Panorama)**, 2003
Ink on Plexiglas,
12 ½ ft. x 8 ¾ ft. x 1 ½ in.
(373 x 262 x 4 cm)

[JMB] It's a paradox. I start with snapshots off the Internet, which I rework and I place, immensely enlarged, on Plexiglas, having scrambled them all up, and then spend a week in the lab reconstituting the image, repainting it, making it anew, giving it new life on Plexiglas. It's not on paper; it's in the world. I like to put things back into the world; the subjects are sometimes negligible.

[CM] Nevertheless, I reckon your work's far more affirmative than you allow.

[XV] It's true the subjects aren't particularly significant, but the objects are.

[CM] Yes, you're not striving for an icon but for a presence—an extremely affirmative presence.

[JMB] The idea is to affirm a presence starting out with insignificant things.

[CM] When you see *Site II*, for example, it is an object possessed of an incredible aura.

[JMB] But from a rather simple starting point, one that is not of itself a dogma. The cypress hedge was the first vertical photo I ever made. Before that, there's not one vertical photographic picture. I didn't do it knowingly. It was always like that. It didn't come from some preordained theory. Afterwards, the lakes, the photos of Japan, are virtually all vertical. All of a sudden, you take note of the sky, something I couldn't bear before, for instance.

[CM] There is something paradoxical about you. You're always afraid it might be too beautiful, yet at the same time what you do is very aesthetic, insofar as it has very close relations with the sensible, and, in a narrower acceptance of aesthetics, with the beautiful.

[JMB] Yes, I'm in France and I know it's a concept that's been shelved. I know, I've often been reproached with it.

[CM] That's not the point I'm trying to make. I'm speaking rather about aesthetics, but not in a pejorative sense; it covers everything that relates to the sensible.

[JMB] I'm one of the very few to have followed this path to beauty.

[XV] It's interesting to see that in the 1960s and 1970s, the conceptual artists one likes, such as Douglas Huebler, for example, tried to escape from the commercial system, from the beauty of form, and move on to the beauty of the idea. Certain pieces are supremely beautiful, but it's taken twenty years for them to get accepted. For me, today, it's not a problem anymore. They're infallibly beautiful.

[CM] It's good it's no problem for you any longer but, remember, ten years ago things were very different.

[JMB] An artist like Michael Asher remains very important, even though he was unable to create a form in which his work could endure. He did some landmark pieces, radical pieces, the radiators in the Bern Kunsthalle, for instance. The conceptual artists who have lasted are those who developed a strong aesthetic system, like On Kawara or Lawrence Weiner; those who found a form.

[CM] Today, a young artist like Jeppe Hein, for example, refers back to Michael Asher.

[XV] But the formal beauty of a piece is not merely in its materialization; it's also in its idea, and today a lot of work doesn't isolate beauty, doesn't really confine it to a formal solution or project. It transcends it as a whole.

[CM] When I talk of aesthetics, I don't mean just beauty, but things in the realm of the senses. You can establish an aesthetic of disaster or whatever you like. Then there's the more specific question of beautiful. When I got into contemporary art, people were beside themselves whenever something was beautiful; the very idea of a potential pleasure was bad. Everyone was under the heel of the Frankfurt School; retention was an

absolute necessity, the absence of pleasure, and all that. It really shocked me. I'll always remember the repulsion I felt visiting the Musée Picasso in Paris, where there were people who spoke about art as if it were something purely intellectual, who saw the fact that Picasso one day painted in pinks and another in blues as almost historically inevitable. After that, you went off to Antibes and there was this woman lecturing to some children. It was there that I had a revelation. She said, look, the artist took up his brush and then he did that, and then he went upward like this.... So, what does that mean with respect to drawing a nose? And I said to myself, there's someone who knows how to talk about art. And this woman was a guide for five-year-olds. We've spent practically fifteen years struggling up this hill to the point that today we can speak about our aesthetic experiences and don't have to deny this dimension in the work. Still, it's really the end to hear an artist condemned for having created a form!

[JMB] The great danger, and I see this often with the younger generation whose work is close to design, to applied or decorative art—always an interesting field—is that, if you push it too far, you can deprive it of sensitivity, and of meaning too. A piece can't hold up without dimensions like meaning and sensibility, the artist's vision, his world, what he makes, how he comes across, how he made himself suffer, how he gives pleasure, et cetera. And it's impossible not to take account of the mythological dimension of the artist.

[XV] The mythological dimension of the artist is all a bit alien to me.

[JMB] I don't mean it's enough to plop a hat on one's head and hey presto! [*Laughter.*]

[XV] Well, that's alright then!

[JMB] For me, the rest is applied art. I'm extremely receptive to the work of a John Galliano or a Ron Arad.... But they interest me because of this freedom. I like the less accomplished side, the more awkward, but perhaps more astonishing side of an artist. Today, as everything's concertina-ing, people want artists to be as flamboyant as couturiers, as designers, or

Lumière 05.03 (Light 05.03), 2003
Ink on Plexiglas,
76 x 105 ½ x 1 ½ in./56 x 78 ½ x 1 ½ in.
(190 x 264 x 4 cm/140 x 196 x 4 cm)

architects. I think that's not right, and that artists are—in my opinion—a little sicker, a little more complicated, a little more difficult.

[xv] That doesn't prevent the search for beauty.

[cm] All the same, Xavier's a rotten example. He's not difficult, he's not complicated, he's not ill. What are your defects?

[xv] I can fly off the handle; my memory's not so good.

[jmb] [*to cm and xv*] Did you never argue during the exhibition?

[xv] No, it all went very smoothly.

[cm] Ah, I'm not against it, but there was no chance.

[xv] I'm not very quarrelsome.

[cm] You are slow, if one may talk about your character. Still, you've done six projects. One might say that your way of progressing is a bit like that, from one idea to the next.

[xv] That was also due to the duration of the exhibition. Suddenly, I was given a tempo which wasn't mine. A few moments ago you talked about beauty. An experience which, for example, was very intense along those lines, was the show I did at the Centre Pompidou. Suddenly, I said to myself, I'm going to try to do something beautiful. As I'd left a field whose criteria of evaluation I knew better, I said myself, I want it to be beautiful. I tried to discover moments, to throw things up into the air, the sole purpose being weightlessness, et cetera. In fact, I now think I should look for this more in my usual practice. It's also what I like about Pierre Huyghe's work: he has this capacity never to evacuate the beauty or the poetry, verging in extreme cases on the syrupy, framing it within a technological environment, an artistic project, and so on.

[CM] That's why his most recent film (*Streamside Day*, 2004) is extremely well done, no doubt about that. And because he takes on all the dimensions you mentioned. The vision of a world, an aesthetic, it's almost a policy, in the sense that he shows his social vision, and then, at the heart of it all, the sensitivity of a Pierre Huyghe; and on the level of form, it's wonderfully carried off.

[XV] Grandiose, too.

[JMB] If one of these parameters is lacking though....

[CM] ... It's no good!

[XV] As I get older, my sensitivity is something I want to make more of. With a past—not cynical, but marked by punk imagery.

[CM] You! You used to be a punk?

[XV] I was never cynical, but I was a punk. Punk, like we used to be in the provinces. It's the artistic trend that affected me the most; not minimal art, not conceptual art, but punk.

[CM] Punk music?

[XV] Punk culture. There were heaps of things which had taken root and were taken as unquestionable truths, and suddenly all that was thrown into question.

[CM] And now you've become bourgeois; you like beautiful things. I'd like people to stop saying that when one likes aesthetic things, one's middle class. I loathe it. It's a caricature you find in the French press, but not in the international press.

[JMB] It's a bit sad because in France it prevents there being artists with real panache. Artists are kings and they've forgotten that. Here, artists are teachers, and curators take advantage and become window dressers. It's all baloney, but some keep at it.

Studio view, Palestine
Making cages for the piece
Suspension, 1997

[xv] I like the idea of panache a lot.

[cm] Those are people who don't come to terms with their social class. It's not a problem with regards to art, it's swallowing the fact one's middle class. You can't do anything about it! Well now, wouldn't you like me to take a picture of you two together?

Jean-Marc Bustamante,
Christine Macel,
and Xavier Veilhan,
summer 2005

1. The IFP (Information Fiction Publicité) was set up in 1984 by Dominique Pasqualini and Jean-François Brun. Originally from the advertising world, they specialized in appropriating advertising language and objects, thereby increasing the scope of the readings of their work. One of their most emblematic creations was a light box featuring a blue sky and clouds.
2. *Le musée qui n'existait pas*, June–September 2002, at the Centre Pompidou, Paris.
3. *Vanishing Point,* September–November 2004, at the Centre Pompidou, Espace 315, Paris.
4. *Jean-Marc Bustamante*, June–September, at the Kunsthaus, Bregenz, Austria.
5. *Dionysiac*, group show featuring 14 artists: John Bock, Christoph Buchel, Maurizio Cattelan, Malachi Farrell, Kendell Geers, Gelatin, Thomas Hirschhorn, Fabrice Hyber, Richard Jackson, Martin Kersels, Paul McCarthy, Jonathan Meese, Jason Rhoades, Keith Tyson; January–May 2005, Centre Pompidou, Paris.
6. Robert Musil, *The Man Without Qualities* (London: Picador, 2002).

Contents

Appendixes

Chronology

Jean-Marc Bustamante was born in Toulouse in 1952.
He now lives and works in Paris.

Major solo exhibitions

1977
Critiques/Images. Art en action,
Galerie Municipale du Château d'Eau, Toulouse, France

1982
Galerie Baudoin Lebon, Paris, France

1984
Exhibition: BAZILEBUSTAMANTE,
Galerie Crousel-Hussenot, Paris, France

1986
Exhibition: BAZILEBUSTAMANTE,
Galerie Bärbel Grässlin, Frankfurt, Germany
Exhibition: BAZILEBUSTAMANTE,
Galerie Philippe Nelson, Villeurbanne, France
Exhibition: BAZILEBUSTAMANTE,
Musée Saint-Pierre, Lyon, France

1987
Exhibition: BAZILEBUSTAMANTE,
Galerie Micheline Szwajcer, Antwerp, Belgium

1988
Galerie Ghislaine Hussenot, Paris, France

1989
Galerie Joost Declercq, Ghent, Belgium
Kunsthalle, Bern, Switzerland

1990
Museum Haus Lange, Krefeld, Germany
Stichting De Appel, Amsterdam, Netherlands
Landshappen 1978–82, Galerie Paul Andriesse, Amsterdam,
Netherlands
Paysages, intérieurs, Musée d'Art Moderne
de la Ville de Paris, France
Galleria Locus Solus, Genoa, Italy

1991
Galería Marga Paz, Madrid, Spain
Œuvres récentes/Stationnaire II, Galerie Ghislaine
Hussenot/Galerie Samia Saouma, Paris, France

1992
Stedelijk Van Abbemuseum, Eindhoven, Netherlands
Galerie Vera Munro, Hamburg, Germany

1993
Donald Young Gallery, Seattle, United States
The Renaissance Society at the University of Chicago,
Chicago, United States
Art Gallery of York University, Toronto, Canada
Sur un plateau (with Franz West),
Galerie Bruges-La-Morte, Brugge, Belgium
Galerie Karlheinz Meyer, Karlsruhe, Germany
Galerie Sollertis, Toulouse, France
Tableaux 1978–82, Musée Départemental d'Art
Contemporain de Rochechouart, Rochechouart, France
FRAC Languedoc-Roussillon, Montpellier, France
A World at a Time, CRG Art Incorporated, New York,
United States

1994
Tableaux et stationnaires, FRAC Languedoc-Roussillon,
Galerie d'Eole, Montpellier, France
Shimada Gallery, Tokyo, Japan
Des arbres de Noël, Galerie Ghislaine Hussenot, Paris,
France
Tableaux 1978–83, Kunsthalle, Bern, Switzerland
A World at a Time, Kunstmuseum, Wolfsburg, Germany
Un monde à la fois, L'Aquarium, École des Beaux-Arts
de Valenciennes, France
La Synagogue de Delme, Centre d'Art Contemporain, Delme
(Lorraine), France

1995
Installation of the permanent piece, *Serena*, in the park at
the Rijksmuseum Kröller-Müller, Otterlo, Netherlands
Un monde à la fois (exhibition banned),
Chapelle du Collège, Carpentras, France
Moderna Galerija, Ljubljana, Slovenia

1996
Galería Antoni Estrany, Barcelona, Spain
Galerie Max Hetzler, Berlin, Germany
Lent retour, Galerie Nationale du Jeu de Paume,
Paris, France

S.I.M.8.97D, 1997
Color photograph,
16 x 24 in. (40 x 60 cm)

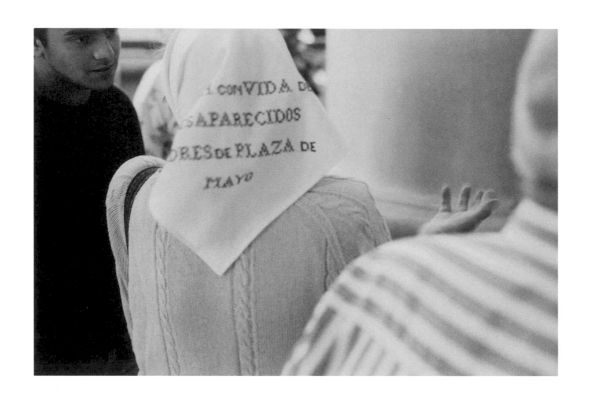

S.I.M.4.97E, 1997
Color photograph,
16 x 24 in. (40 x 60 cm)

1997
Something is Missing, Anadyel Gallery, Jerusalem, Israel
Matthew Marks Gallery, New York, United States
Villa Arson, Nice, France
Suspension, Galerie Bob van Orsouw, Zurich, Switzerland
Galerie Max Hetzler, Berlin, Germany
Shimada Gallery, Tokyo, Japan
Seomi Gallery, Seoul, South Korea
Galerie Vera Munro, Hamburg, Germany

1998
Galerie Xavier Hufkens, Brussels, Belgium
Centre Culturel Français, Turin, Italy
Shimada Gallery, Tokyo, Japan
Something is Missing, Tate Gallery, London,
Great Britain

1999
Sources et Ressources, Galerie de l'École des Beaux-Arts,
Quimper, France
Matthew Marks Gallery, New York, United States
Galerie Daniel Templon, Paris, France
Galerie Nathalie Obadia, Paris, France
Raum Aktueller Kunst, Vienna, Austria
Galerie Karlheinz Meyer, Karlsruhe, Germany
Oeuvres photographiques: 1978–99, Centre National
de la Photographie, Paris, France

2000
Inédits, Tableaux 1978–82, Galerie Xavier Hüfkens,
Brussels, Belgium
Galerie Bob van Orsouw, Zurich, Switzerland
Galerie Vera Munro, Hamburg, Germany
LP's 2000, Long Playing, Lost Paradise, Lake Photographs,
Neues Kunstmuseum, Lucerne, Switzerland
Early Works, Matthew Marks Gallery, New York,
United States

2001
Donald Young Gallery, Chicago, United States
Long Playing, Deichtorhallen, Hamburg, Germany
Timothy Taylor Gallery, London, Great Britain
Galerie Max Hetzler, Berlin, Germany
Galería Estrany de la Mota, Barcelona, Spain
Galerie Daniel Templon/Galerie Nathalie Obadia,
Paris, France

2002
Galerie Paul Andriesse, Amsterdam, Netherlands
Galería Helga de Alvear, Madrid, Spain
Yokohama Museum of Art, Yamaguchi Prefectural
Museum of Art, Yamaguchi, Japan
Matthew Marks Gallery, New York, United States

2003
Private Crossing, CASA. Centro de Arte de Salamanca,
Salamanca, Spain
French Pavilion, fiftieth Venice Biennale, Italy
Galerie Karlheinz Meyer Karlsruhe, Germany
(with Candida Höfer)
Galerie Thaddaeus Ropac, Salzburg, Austria
Nouvelles scènes, Timothy Taylor Gallery, London,
Great Britain

2004
Galerie Vera Munro, Hamburg, Germany

2006
Kunsthaus, Bregenz, Austria

Main Group Shows

1980
Eleventh Paris Biennial, Arc-Musée d'Art Moderne
de la Ville de Paris/Centre Pompidou, Paris, France
43 rue La Bruyère, Paris, France
Portrait d'artiste, Galerie NRA, Paris, France

1982
With Bernard Bazile, Marseille Art Présent,
Musée Cantini, Marseille, France

1983
Adamah, Elac, Lyon, France
France Tours, Art Actuel, Biennale Nationale
d'Art Contemporain 82–84, Tours, France

1984
Lumières et sons 84, FRAC Aquitaine, Château de Biron,
Biron, France

1985
With Bernard Bazile, *Rendez-vous*, Künstlerwerkstatt
Lothringerstrasse, Munich, Germany
Les seconds Ateliers internationaux des Pays de Loire,
Abbaye Royale de Fontevraud, Fontevraud-L'Abbaye,
France
With Bernard Bazile, *Alles und noch viel mehr:
Das poetische ABC*, Kunsthalle Bern, Switzerland
With Bernard Bazile, Graz Biennial, Austria
12 Artists in the Space, Seibu Museum, Tokyo, Japan
Galerie Crousel-Hussenot, Paris, France

1986
Art français: Position, B.I.G., Berlin, Germany
Aperto, with Bernard Bazile, Venice Biennale, Italy
Een Keuze, with Bernard Bazile, R.A.I., Amsterdam,
Netherlands
Made in France 68–86, Fondation du Château de Jau, Jau,
France
With Bernard Bazile, Niek Kemps, and Jan Vercruysse,
Centre d'Art Contemporain, Palais Wilson, Geneva,
Switzerland
With Bernard Bazile, sixth Sydney Biennial, Australia
With Bernard Bazile, *Sonsbeek 86*, Park Sonsbeek,
Arnheim, Netherlands
With Bernard Bazile, *A Distanced View*, The New Museum
of Contemporary Art, New York, United States

1987
Kunst mit Fotografie, Galerie Ralph Wernicke,
Stuttgart, Germany
With Bernard Bazile, *L'époque, la mode, la morale,
la passion*, Centre Pompidou, Paris, France
Musée Saint-Pierre, Lyon, France
Frankfurter Kunstverein, Frankfurt, Germany
Documenta VIII, Kassel, Germany

1988
Nooit Geziene Werken, Joost Declerq Gallery,
Ghent, Belgium

1990
French Spring, collections of the FRAC Nord-Pas
de Calais, Scottish National Gallery of Modern Art,
Edinburgh, Great Britain
Un art de la distinction? Abbaye St André,
Meymac, France
De Afstand, Witte de With, Rotterdam, Netherlands
Camera Works, Galerie Samia Saouma, Paris, France
Possible Worlds: Sculpture from Europe, Institute
of Contemporary Art/Serpentine Gallery, London, Great
Britain
Weitersehen 1980–90, Museum Haus Lange/Museum Haus
Esters, Krefeld, Germany
Le Diaphane, Musée Municipal des Beaux-Arts, Tourcoing,
France

1991
Vanitas, Galerie Crousel-Robelin/Galerie Bama, Paris,
France
Metropolis, Martin Gropius Bau, Berlin, Germany
Lieux communs, figures singulières, Arc-Musée
d'Art Moderne de la Ville de Paris, Paris, France
Paysages/Lanschappen, Vision contemporaine,
Galerie du Crédit Commercial, Brussels, Belgium
L'invention du paysage, FRAC Corse, Corte, France
Sguardo di Medusa, Castello di Rivoli, Turin, Italy
Exhibition of Acquisitions, Stedelijk van Abbemuseum,
Eindhoven, Netherlands
…in anderem Raümen, Collection of the Krefeld Museum,
Museum Haus Lange/Museum Haus Esters, Krefeld,
Germany
Collection du CAPC, CAPC-Musée d'Art Contemporain,
Bordeaux, France
Galeria Locus Solus, Genoa, Italy

1992
Documenta IX, Kassel, Germany
Donald Young Gallery, Seattle, United States
Ce n'est pas la fin du monde, Galerie Art et Essai, University
of Rennes II/Galerie du Théâtre National
de Bretagne/La Criée, Centre d'Art Contemporain,
Rennes, France
Musée des Beaux-Arts, Cave Sainte-Croix,
Espace Faux-Mouvement, Metz, France
*Schwerpunkt Shulptur, Hundertvierzig Werke
von achtzig Künstlern: 1950–90*, Kaiser Wilhelm Museum,
Krefeld, Germany
Une seconde pensée du paysage, Centre d'Art Contemporain,
Domaine de Kerguéhennec, France
Wasteland: Landscape from Now On, third Photography
Biennial, Rotterdam, Netherlands
350, place d'Youville, cinq créateurs français à Montréal,
Montreal, Canada
Paysage intérieur, Rijksmuseum Kröller-Müller,
Otterlo, Netherlands

1993
Kunstbücher I, Museum Haus Esters, Krefeld, Germany
350, place d'Youville, cinq créateurs français à Montréal,
Institut Français d'Architecture, Paris, France
With Rosemarie Trockel and James Welling, Galerie Samia
Saouma, Paris, France
A propos des paysages, Institut Néerlandais, Paris, France
Azur, Fondation Cartier, Jouy-en-Josas, France
L'image dans le tapis, Cercle de l'Arsenal, forty-fifth Venice
Biennale, Italy
Galerie Xavier Hufkens, Brussels, Belgium
The Sublime Void: On the Memory of the Imagination,
Antwerp 93, Koninklijk Museum voor Schone Kunsten,
Antwerp, Belgium
*Allégorie de la richesse, Barock und Kunst
der Gegenwart*, Friedrichstadt Passagen, Humboldt-
Universität, Parochialkirche, Berlin, Germany

1994
Espace révélés, Galerie du Théâtre National de Bretagne,
Rennes, France
Wandstücke III, Galerie Bob van Orsouw, Zurich,
Switzerland
Collection de la Fédération des Coopératives de Migros,
Museo Cantonale d'Arte, Lugano, Switzerland
The Epic and the Everyday: Contemporary Photographic Art,
Hayward Gallery, London, Great Britain
Theoretical Events Gallery, Naples, Italy
Même si c'est la nuit, CAPC-Musée d'Art Contemporain,
Bordeaux, France
Twenty-second International Biennial, São Paulo, Brazil
Los géneros de la pintura. Una visión actual, Centro
Atlántico de Arte Moderno, Las Palmas, Museo Español
de Arte Contemporáneo, Seville, Spain
Kraji. Places, Moderna Galerija, Ljubljana, Slovenia
L'arca de Noé, Fundaçao Serralves, Porto, Portugal

1995
With Matt Mullican and Juan Munoz, *Autour
du paysage*, Galerie Ghislaine Hussenot, Paris, France
With Rodney Graham, Jan Vercruysse, Thomas Schütte,
Centre Genevois de Gravure Contemporaine, Geneva,
Switzerland
Architectures plurales, Centre Cultural, Palma,
Majorca, Spain
Du Paysage incertain, fragments, Château de Vassivière,
Centre d'Art Contemporain, France
Des limites du tableau. Les possibles de la peinture,
Musée Départemental d'Art Contemporain
de Rochechouart, France
Morceaux choisis du Fonds National d'Art Contemporain,
Le Magasin-Centre National d'Art Contemporain,
Grenoble, France
*L'immagine Riflessa, Una selezione di fotografia
contemporanea dalla Collezione LAC, Svizzera*,
Museo Pecci, Prato, Italy

1996
Paysages, Galerie Gilles Peyroulet & Cie, Paris, France
Le lieu du combat, Centre d'Art Contemporain,
Domaine de Kerguéhennec, France

1997
Documenta X, Kassel, Germany
From Here to There, Calouste Gulbenkian Foundation,
Lisbon/Centro Português de Fotografia, Porto, Portugal
Absolute Landscape— between Illusion and Reality,
Yokohama Museum of Art, Yokohama, Japan
*Images Objets Scènes, quelques aspects de l'art en France
depuis 1978*, Le Magasin-Centre National
d'Art Contemporain, Grenoble, France
10 Jahre Stiftung Kunsthalle, Kunsthalle,
Bern, Switzerland

1998
*Wounds: Between Democracy and Redemption in
Contemporary Art*, Moderna Museet, Stockholm, Sweden
Maverick, Matthew Marks Gallery, New York,
United States
René Magritte et l'art contemporain, PMMK,
Museum voor Moderne Kunst, Ostend, Netherlands
*Premises: Invested Spaces in Visual Arts, Architecture and
Design from France 1958–98*, Solomon
R. Guggenheim Museum, New York, United States
*Minimal Maximal: Minimal Art and its Influence on
International Art of the 1990s*, Neue Museum Weserburg,
Bremen, Germany/Staatliche Kunsthalle, Baden Baden,
Germany/Centro Gallego de Arte Contemporánea,
Santiago da Compostela, Spain
Home Sweet Home, Galerie Gilles Peyroulet et Cie,
Paris, France

1999
Matthew Marks Gallery, New York, United States
Trafic, FRAC Haute-Normandie, Sotteville-lès-Rouen,
France
Imago, encuentros de fotografía y video 99, Centro de
Fotografía, Universidad de Salamanca, Salamanca, Spain
Abstraction, Galerie Daniel Templon, Paris, France
With Yves Belorgey et Gabriel Orozco, *Ruines*, FRAC Paca,
Marseille, France
Une histoire parmi d'autres, Collection Michel Poitevin,
FRAC Nord-Pas de Calais, Dunkerque, France

2000
L'invitation à la ville, Brussels, Belgium
Dépaysement, Domaine de Kerguéhennec, France/Museum
Dhondt-Dhaenens, Deurle, Belgium
Enclosed and Enchanted, Museum of Modern Art, Oxford,
Great Britain
Abstrakte Fotografie, Kunsthalle, Bielefeld, Germany
Fine di Partita, Endgame, Fin de Partie, Florence, Italy

2001
With Tom Baldwin and Beat Streuli, Gallery Goldman
Tevis, Los Angeles, United States
Places in the Mind: Photographs from the Collection, The
Metropolitan Museum of Art, New York, United States
Minimalismos, un signo de los tiempos, Museo Nacional
Centro de Arte Reina Sofia, Madrid, Spain
*Eine Wanderung zwischen Landschaft und Kunst,
Spiral Jetty und Potsdamer Schrebergärten*, Kunstmuseum
Basel, Switzerland
Oublier l'exposition: Contemporary Photography from France,
Huis Marseille, Amsterdam, Netherlands

2002
Regarding Landscape, Museum of Contemporary Canadian
Art, Toronto, Canada
Wallflowers, Kunsthaus, Zurich, Switzerland
Límits de la percepció, Fundació Joan Miró,
Barcelona, Spain

2003
Colocataires, Centre d'Art Contemporain de Castres,
Castres, France
Regarde, il neige (schizogéographie de la vie quotidienne),
Centre National d'Art et du Paysage, Vassivière, France
Art Focus 4, Underground Prisoner's Museum, Jerusalem,
Israel

2004
À Angles vifs, CAPC-Musée d'Art Contemporain,
Bordeaux, France
Objects versus Design, MAM-Musée d'Art Moderne
de Saint-Étienne, Saint-Étienne, France

2005
A Guest + a Host = a Ghost, Hedge House, Wijlre,
Netherlands
Chassez le naturel…, Château de Chambord, Chambord,
France
De lo real y lo ficticio: Arte contemporáneo de Francia,
presentation of a selection of works from the Fonds
National d'Art Contemporain, Museo de Arte Moderno,
Mexico

Selected bibliography

Bustamante. Texts by Alain Cueff and Ulrich Loock. Bern: Kunsthalle Bern, 1989.

Jean-Marc Bustamante. Text by Julian Heynen. Krefeld: Museum Haus Lange, 1990.

Jean-Marc Bustamante. Texts by Alain Cueff and Suzanne Pagé. Paris: Arc-Musée d'Art Moderne de la Ville de Paris, 1990.

The Image, the Place/Parcours. Jean-Marc Bustamante. Texts by Suzanne Ghez and Jean-François Chevrier. Chicago and Toronto: The Renaissance Society at the University of Chicago/Art Gallery of York University, 1993.

Jean-Marc Bustamante: Tableaux 1978–1982. Text by Jacinto Lageira. Rochechouart and Bern: Musée Départemental de Rochechouart/FRAC Languedoc-Roussillon/Kunsthalle Bern, 1994.

Lumières 1987–1993. Text by Catherine de Smet. Paris: Centre d'Art Imprimé, 1994.

Bustamante: A World at a Time. Texts by Uta Grosenick and Catherine Francblin. Wolfsburg: Kunstmuseum Wolfsburg, 1994.

Serena. Text by Denys Zacharopoulos. Otterlo: Kröller-Müller Museum, 1995.

Jean-Marc Bustamante. Texts by Christine Macel, Jacinto Lageira, and Marc Perelman. Paris: Dis Voir, 1995.

Jean-Marc Bustamante. Texts by Jan Debbaut and Danielle Cohen-Levinas. Eindhoven: Van Abbemuseum, 1995.

Jean-Marc Bustamante: Lent retour. Texts by Jean-Marc Bustamante. Paris: Galerie Nationale du Jeu de Paume, 1996.

Amandes amères/Bitter Almonds/Bittere Mandeln. London: Phaidon, 1997.

Jean-Marc Bustamante: Something Is Missing. Text by Manel Clot. Salamanca: Universidad de Salamanca, 1999.

Jean-Marc Bustamante: Oeuvres photographiques 1978–1999. Text by Jean-Pierre Criqui. Paris: Centre National de la Photographie, 1999.

Jean-Marc Bustamante: L.P. Text by Jean-Pierre Criqui. Lucerne: Neues Kunstmuseum Luzern, 2001.

Jean-Marc Bustamante: Long Playing. Texts by Zdenek Felix, Sophie Berrebi, and Jean-Marc Bustamante. Hamburg: Deichtorhallen, 2001.

Jean-Marc Bustamante: Private Crossing. Texts by Doris von Drahten and Taro Amano. Yokohama and Yamaguchi: Yokohama Museum of Art/Yamaguchi Museum of Art, 2002.

Jean-Marc Bustamante: Private Crossing. Texts by Doris von Drathen and Jean-Pierre Criqui. Salamanca: Centro de Arte de Salamanca, 2003.

Jean-Marc Bustamante. Texts by Jean-Pierre Criqui, Michel Gauthier, Alfred Pacquement, Michel Poivert, and Katy Siegel. Paris: Gallimard, 2003.

Jean-Marc Bustamante: Nouvelles Scénes. Text by Matthew Arnatt. London: Timothy Taylor Gallery, 2003.

Index of works

Pages

S.I.M.1.01, 2001
Color photograph,
16 x 24 in. (40 x 60 cm)

S.I.M.10.98, 1998
Color photograph,
16 x 24 in. (40 x 60 cm)

[69] **T.34.80**, 1980
Color photograph,
41 ¼ x 40 in. (1.03 x 1 m)

[70] **S.I.M.12.97**, 1997
Color photograph, 16 x 24 in. (40 x 60 cm)

[71] **L.P.II**, 2000
Color photograph, 90 ¾ x 72 in.
(2.27 x 1.8 m)

[72] **T.17.79**, 1979
Color photograph,
41 ¼ x 40 in. (1.03 x 1 m)

[73] **T.C.R.03**, 2003
Color photograph,
90 ¾ x 72 in. (2.27 x 1.8 m)

[75] **Stationnaire I (Stationary I)**,
1990, detail
Cement, resin, brass; 16 elements,
each 32 ½ x 10 ¾ x 15 ½ in.
(81 x 27 x 39 cm)
Color photographs; six elements,
each 60 x 48 in. (1.5 x 1.2 m)
Collection Caisse des Dépôts et
Consignations,
Musée de Saint-Etienne
Photo: Kristien Daem

[76] **Stationnaire II (Stationary II)**,
1991
Color photographs, cement boxes,
resin, 48 x 22 ½ x 26 ½ in.
(120 x 56 x 66 cm)
Collection Musée d'Art Moderne
de la Ville de Paris

[77] **Stationnaire II (Stationary II)**,
1991
Color photographs, cement boxes,
resin; each box 26 ½ x 22 ½ x 3 ¼ in.
(66 x 56 x 8 cm)

[78] **Stationnaire II (Stationary II)**, 1991
Color photographs, cement boxes,
resin; each box 26 ½ x 22 ½ x 3 ¼ in.
(66 x 56 x 8 cm)

[79] **Paysage droit debout (Landscape
Straight Standing)**, 1993
Steel, galvanized paint,
87 ½ x 14 ¾ x 12 ½ in. (219 x 37 x 31 cm)

[80] **Bac à sable I (Sandbox I)**, 1990
Cement, wood, sand,
92 ½ x 73 x 11 ¼ in.
(231.5 x 182.5 x 28 cm)
Collection Van Abbemuseum,
Eindhoven

[81] **T.126.91**, 1991
Color photograph,
55 ¼ x 44 ½ in. (1.38 x 1.11 m)

[82] **T.133.91**, 1991
Color photograph,
55 ¼ x 44 ½ in. (1.38 x 1.11 m)

[83] **Paysage droit devant (Landscape
Straight Front)**, 1993
Steel, minium paint,
88 x 57 ½ x 16 ¾ in. (220 x 144 x 42 cm)

[85] **L.P.IV**, 2000
Color photograph,
90 ¾ x 72 in. (2.27 x 1.8 m)

[86] **Paysage XA**, 1990
Steel, cement, resin, minium paint,
72 x 35 ¼ x 14 ½ in. (180 x 88 x 36 cm)
View of the exhibition,
Museum Haus Esters, Krefeld

[87] **Arbres de Noël
(Christmas Trees)**, 1994–96
Steel, paint, varnish, concrete base;
21 elements, each 92 x 19 ¼ x ½ in.
(230 x 48 x 1 cm)
Base: 6 x 24 x 8 in. (15 x 60 x 20 cm)
View of the exhibition,
Domaine de Kerguéhennec

[88, 89] **Site III**, 1992
Steel, minium paint, wax,
15 ft. x 11 ft. x 7 ¼ in. (450 x 330 x 18 cm)
Collection Foundation
for the Musée d'Art Moderne, Bern

[90] **Origines IV, V**, and **VI**, 1992
Metal, lacquer,
71 ¼ x 59 ¼ in. (178 x 148 cm)
70 ¾ x 57 ¼ in. (177 x 143 cm),
and 68 x 61 ½ in. (170 x 154 cm)
Intérieur III, 1988
Metal, Formica,
48 x 32 x 18 in. (120 x 80 x 45 cm)
View of the exhibition,
Van Abbemuseum, Eindhoven

[91] **Origines**, 1992
Steel, lacquer, 71 ¼ x 64 in. (178 x 160 cm)
Photo: Kristien Daem

[92] **Aller Retour II
(Back and Forth II)**, 1990
Cement, wood; each element
29 x 38 x 12 in. (72.5 x 95 x 30 cm
Aller Retour I (Back and Forth I), 1990
Cement, wood,
37 ½ x 42 x 24 ¾ in. (93,5 x 105 x 62 cm)
View of the exhibition,
Museum Haus Lange, Krefeld

[93] **Paysage XIX (Landscape XIX)**, 1990
Steel, minium paint,
Left: 28 ½ x 24 ¾ x 6 ½ in.
(71 x 62 x 16 cm)
Right: 28 ½ x 46 ¾ x 6 ½ in.
(71 x 117 x 16 cm)

[94] **Paysage XX, (Landscape XX)**, 1990
Steel, buffed minium paint, wax,
28 ½ x 80 ¾ x 6 ½ in. (71 x 202 x 16.5 cm)
Kröller-Müller Museum Collection,
Otterlo

[95] **Mesa III**, 2001
Steel, painted glass, candles,
59 ¼ x 80 x 36 in. (148 x 200 x 90 cm)

[96, 97] **Les Autres (The Others)**, 1992
Corten steel,
67 ¼ x 47 ¾ x 1 in./74 ½ x 53 x 1 in.
(168 x 119.5 x 2.5 cm/186 x 132.5 x 2.5 cm)
View of the exhibition,
Van Abbemuseum, Eindhoven

[98] **Double Miroir (Double Mirror)**,
1991
Steel, minium paint,
70 x 64 x 6 in. (175 x 160 x 15 cm)

[99] **Panorama Transfert**, 1998
Ink on Plexiglas,
60 ½ x 98 ¾ x 1 ½ in. (151 x 247 x 4 cm)

[100] **Site I**, 1991
Steel, minium paint, wax,
15 ¼ ft. x 14 ⅓ ft. x 16 ½ in.
(456 x 430 x 41 cm)
Collection CAPC-Musée d'Art
Contemporain, Bordeaux

[100] **Lumière 14C.92 (Light 14C.92)**, 1992
Ink on Plexiglas,
74 x 55 ¼ x 1 ½ in. (185 x 138 x 4 cm)
Lumière 9.91 (Light 9.91), 1991
Ink on Plexiglas,
74 x 58 x 1 ½ in. (185 x 145 x 4 cm)
View of the exhibition, Centre National
de la Photographie, Paris, 1999
Photo: Laurent Lecat

[101] **Lumière 6.91 (Light 6.91)**, 1991
Ink on Plexiglas,
58 x 74 x 1 ½ in. (145 x 185 x 4 cm)

[102] **Suspension II2.98**, 1998
Ink on Plexiglas,
69 ¼ x 54 ½ x 1 ½ in. (173 x 136 x 4 cm)

[103] **Aérogramme mentholé
(Mentholated Aerogram)**, 1997
Ink on Plexiglas,
48 x 76 x 1 ½ in. (120 x 190 x 4 cm)

[104] **Aérogramme Granit
(Granite Aerogram)**, 1997
Ink on Plexiglas,
48 x 72 x 1 ½ in. (120 x 180 x 4 cm)

[105] **Trophée 3 (Trophy 3)**, 2005
Galvanized steel, ink on Plexiglas,
42 ¾ x 51 ¼ in. (1.07 x 1.28 m)

[106] Draft for **Origines**, 1992

[107] **Serena**, 1994
Vulcanized rubber on metal
Length: 400 ft. (120 m)
Diameter: 2 ¾ in. (7 cm)
Permanent work,
Kröller-Müller Museum, Otterlo

[108] **Manège II (Merry-go-Round II)**, 2003
Zinc-plated steel, metal, glass,
11 ⅔ x 10 ⅓ x 8 ⅔ ft. (3.5 x 3.1 x 2.6 m)

[109] **Panorama Barbed Threads**, 2000
Ink on Plexiglas,
58 x 114 x 2 ½ in. (145 x 285 x 6 cm)
Photo: Laurent Lecat

[110] **S.I.M.19.97**, 1997
Color photograph, 16 x 24 in. (40 x 60 cm)

[111] **S.I.M.8.97**, 1997
Six color photographs;
each photograph 16 x 24 in. (40 x 60 cm)

[112] **Suspension I**, 1996
Eleven metal cages with live finches
(diamond mandarins)
78, 74, 72, 70, 68 x 12 x 18 ½ in.
(195, 185, 180, 175, 170 x 30 x 46 cm)

[113] Project for a public sculpture, 2005
Steel, paint, 26 ⅔ x 20 x 5 ft.
(8 x 6 x 1.5 m)

[114] **Aérogramme Aphone
(Aphonic Aerogram)**, 1997
Ink on Plexiglas, 58 x 74 x 1 ½ in.
(145 x 180 x 4 cm)

[115] **La Maison Close
(The Brothel)**, Orleans, 2000
Concrete, frosted glass,
randomly programmed interior lighting,
21 ¾ x 26 ⅔ x 10 ½ ft.
(6.55 x 8 x 3.15 m)

[116] **T.50.82**, 1982
Color photograph,
41 ¼ x 52 in. (1.03 x 1.3 m)

[117] **Leda**, 1992
Lacquered glass, 12 x 9 ft. (3.6 x 2.7 m)
Collection Stedelijk Museum
voor Actuele Kunst, Ghent

[118] **T.1.78,** 1978
Color photograph,
41 ¼ x 52 in. (1.03 x 1.3 m)

[119] **Lava I**, 2003
Galvanized steel, ink on Plexiglas,
29 ¾ ft. x 14 ½ ft. x 7 ¼ in.
(892 x 438 x 18 cm)
Collection Tate Gallery, London
Photo: Antony Makinson,
Prudence Cuming Associates

[120] **Panorama Moby Dick**, 2004
Ink on Plexiglas,
4 ¾ x 8 ½ ft. (1.45 x 2.54 m)

[121] **Panorama Valentine**, 1998
Triptych, ink on Plexiglas,
6 ft. x 9 ½ ft. x 1 ½ in. (183 x 289 x 4 cm)
Photo: Laurent Lecat

[126] **T.2A.78**, 1978
Color photograph,
41 ¼ x 52 in. (1.03 x 1.3 m)

[127] **Regrets**, 1991
Steel, minium paint, wax,
12 x 49 ½ x 63 ¾ in. (30 x 126 x 162 cm)

[129] **T.42.81**, 1981
Color photograph, 41 ¼ x 40 in. (1.03 x 1 m)

[130] **T.63.82**, 1982
Color photograph,
41 ¼ x 52 in. (1.03 x 1.3 m)

[132, 133] **T.03.78**, 1978
Color photograph,
41 ¼ x 52 in. (1.03 x 1.3 m)

[134] **Ouverture I**, 1993
Wood, color photograph,
17 ¼ x 84 x 48 in.
(43 x 210 x 120 cm)
Collection Fonds National d'Art
Contemporain, Paris
View of the exhibition,
Haus Esters, Krefeld

[135] **T.32.80**, 1980
Color photograph,
41 ¼ x 52 in. (1.03 x 1.3 m)

[136] **Intérieur II**, 1987
Varnished solid oak,
86 ¾ x 34 x 76 in. (217 x 85 x 190 cm)
Collection Fonds National
d'Art Contemporain, Paris

[137] **Portraits T.C.B1.02**, 2002
Color photograph,
90 ¾ x 72 in. (2.27 x 1.8 m)

[138] **Lumière 3.87 (Light 3.87)**, 1987
Ink on Plexiglas,
70 x 58 x 1 ½ in. (175 x 145 x 4 cm)

[139] **Lumière 5A.89 (Light 5A.89)**, 1989
Ink on Plexiglas,
58 x 74 x 1 ½ in. (145 x 185 x 4 cm)

[140] **T.21.78**, 1978
Color photograph,
41 ¼ x 52 in. (1.03 x 1.3 m)

[141] **Paysage I (Landscape I)**, 1988
Glass, steel, 9 x 6 ⅔ x 1 ½ ft.
(270 x 200 x 44 cm)
Le Vêtement (The Garment), 1988
Steel, seventeenth-century court
dress, minium paint
Photo: Florian Kleinefenn

[142, 143] **Lumière 02.03 (Light 02.03)**, 2003
Ink on Plexiglas,
78 x 111 x 1 ½ in./56 x 68 x 1 ½ in.
(195 x 280 x 4 cm/140 x 170 x 4 cm)

[144] **Lumière 11.91 (Light 11.91)**, 1991
Ink on Plexiglas,
58 x 74 x 1 ¾ in. (145 x 185 x 4.5 cm)
Des Limites, 1990
Colored cement,
60 x 30 x 1 ¾ in. (150 x 75 x 4.5 cm)

[145] **Le Verre bleu (The Blue Glass)**,
1987
Painted glass, 11 ⅓ ft. x 8 ⅔ ft. x 1 ¼ in.
(340 x 260 x 3 cm)

[146] **Site II**, 1992
Steel, minium paint, lacquer, wax,
15 ¼ x 14 ⅓ x 1 ⅓ ft. (456 x 430 x 41 cm)
Musée National d'Art Moderne,
Centre Pompidou, Paris

[148] **Dispersion II**, 2003
Ink on Plexiglas; five elements,
each 88 x 24 x ½ in. (220 x 40 x 1 cm)

[149] **Partition I**, 1996
Painted metal, glass,
70 x 68 in. (1.75 x 1.7 m)
Photo: Laurent Lecat

[150] **Sans titre (Untitled, diptych)**,
1993
Steel, paint; each element
82 ½ x 53 ½ x ½ in. (206 x 134 x 1 cm)
Collection Van Abbemuseum,
Eindhoven

[151] **Sans titre (Untitled, triptych)**,
1993
Steel, paint, varnish; each element
77 ½ x 28 x ½ in. (194 x 70 x 1 cm)

[152] **Inventaire**, 1989
Wood, mirrors, 8 ¾ x 8 ½ x 1 ⅛ ft.
(262 x 254 x 32 cm)
Photo: Paul Maurer

[156] BAZILEBUSTAMANTE
Studio view, 1985

[159] BAZILEBUSTAMANTE
Sans titre (Untitled), 1985
Wood, Plexiglas, 11 ⅓ x 9 ⅓ x 1 ⅔ ft.
(340 x 280 x 50 cm)
Collection Musée
d'Art Contemporain, Lyon

[162] **Panorama From Here to There**,
2003
Ink on Plexiglas (triptych),
20 ft. x 11 ⅓ ft. x 2 ½ in. (600 x 340 x 6 cm)
Central panel: 11 ⅓ x 6 ⅓ ft. (3.4 x 1.9 m)
Side panels: 5 ½ x 6 ⅓ ft. (1.67 x 1.9 m)
View of the exhibition,
French Pavilion, Venice Biennale, 2003

[166, 167] **Panorama Surroundings**, 1998
Ink on Plexiglas, 62 ¾ x 96 x 1 ½ in.
(157 x 240 x 4 cm)

[171] **Suspension**, 1997
Painted metal and live finches
(diamond mandarins),
78 x 12 x 18 ½ in. (195 x 30 x 46 cm);
74 x 12 x 18 ½ in. (185 x 30 x 46 cm);
70 x 12 x 18 ½ in. (175 x 30 x 46 cm)
Collection Musée Départemental d'Art

[175] **L.P.I**, 2000
Color photograph,
90 ¾ x 72 in. (2.27 x 1.8 m)

[179] **T.3.79**, 1979
Color photograph,
41 ¼ x 52 in. (1.03 x 1.3 m)

[182] **Panorama Perroquets
(Parrot Panorama)**, 2003
Ink on Plexiglas,
12 ½ ft. x 8 ¾ ft. x 1 ½ in.
(373 x 262 x 4 cm)
View of the exhibition,
French Pavilion, Venice Biennale, 2003

[186] **Lumière 05.03 (Light 05.03)**, 2003
Ink on Plexiglas,
76 x 105 ½ x 1 ½ in./56 x 78 ½ x 1 ½ in.
(190 x 264 x 4 cm/140 x 196 x 4 cm)

[189] Studio view, Palestine
Making cages for the piece
Suspension, 1997

[190] Jean-Marc Bustamante,
Christine Macel, and Xavier Veilhan,
summer 2005
Photo: Studio Belvédère, Paris

[195] **S.I.M.8.97D**, 1997
Color photograph,
16 x 24 in. (40 x 60 cm)

[196] **S.I.M.4.97E**, 1997
Color photograph,
16 x 24 in. (40 x 60 cm)

[203] **S.I.M.1.01**, 2001
Color photograph,
16 x 24 in. (40 x 60 cm)

[204] **S.I.M.10.98**, 1998
Color photograph,
16 x 24 in. (40 x 60 cm)

Cover and endpapers

Cage, 1997, detail
Painted metal and live finches
(diamond mandarins),
72 x 12 x 18 ½ in.
(180 x 30 x 46 cm)